Neil Bartlett

SOLO VOICES

MONOLOGUES
1987–2004

T0347807

OBERON BOOKS
LONDON

First published in 2005 by Oberon Books Ltd
Electronic edition published in 2013

Oberon Books Ltd
521 Caledonian Road, London N7 9RH
Tel: +44 (0) 20 7607 3637 / Fax: +44 (0) 20 7607 3629
e-mail: info@oberonbooks.com
www.oberonbooks.com

A catalogue record for this book is available from the British Library.

PB ISBN: 978-1-84002-465-4
E ISBN: 978-1-84943-955-8

Cover photograph by Mike Laye

eBook conversion by Replika Press PVT Ltd, India.

Contents

Writing a Solo Voice

Alongside my work as a director making full-scale theatre pieces – a necessarily collaborative and expensive process – I have always employed the guerilla tactics of the monologue. The monologue allows one to respond, both as an author and as a performer, immediately – personally, quickly, passionately – to particular circumstances, places and people.

The first six pieces in this collection were pieces that I performed as well as wrote. Like many performance and theatre artists who started work in the early 1980s, I was heavily (if unconsciously) indebted to the ethos and working practices of punk. The work was personal, adversarial, home-made, often collaged out of recycled fragments of 'found' text and music, and always performed in marginal venues. And it was cheap: the earliest pieces cost almost nothing to make or perform, and in consequence I could play them in places other forms of perform-ance couldn't reach – nightclubs, galleries, benefits, studios and community centres for one-night-stands; for longer runs, derelict or unloved buildings commandeered for the purpose. Later, the cheapness of the form meant that my often angry, often provocative voice could be smuggled onto television and radio with great ease. Sometimes, when I found out that a particular piece fundamentally worked, and that people actually wanted to come and see it, I would use the solo performance as the working model for a full-scale performance or theatre piece. Both *A Vision Of Love Revealed In Sleep* and *Night After Night* became theatre pieces; *The Seven Sacraments Of Nicolas Poussin* grew into a staged oratorio with opera singers, dancers, a choir, a chamber orchestra and a swarming chorus of schoolchildren – and the best set of my career to date, the crossing of Southwark Cathedral.

Though they vary greatly in length and tone, the monologues collected here have several things in common. Most obviously, they are all about love, and courage. They all make the body – flesh – central to their arguments. They all reflect my fascination with the byways, rather than the highways, of London. They are

vocally chameleon, delighting in switches and lurches of tone, sudden moves in and out of character as well as between different characters. They seem to me characteristically to splice together an insistent, incantatory speaking rhythm (stolen in the first place I think from the Church of England, whose vicars provided my first childhood experience of solo performance art) with various kinds of garrulous, high or low, outraged or outrageous, theatrical effeminacy – both male and female. Their speaking voice always seems to me to be definitely that of a solitary, rather than merely *solo*, man. And, of course, that man is gay. Taken together, they form some kind of personal running commentary on the history, pre-history and modern realities of one gay man's London. That said, these pieces, like all of my work, assume that 'gayness' isn't just a question of what you talk about, but of how you talk; of not just *a* particular world, but also a way of looking at – of speaking of – *the* world.

The last three pieces in the collection were written for other people to perform: for close colleagues, performers whose voices I knew and which inspired me to create pieces especially for them. (It is, incidentally, surely no accident that the basic form, that of an intimate first-person confession, remains the same in these later pieces, even when it is no longer literally 'I' who am speaking; which means, I suppose, that no matter how intensely personal they seem, the 'I' of the early monologues was also, already, always a character.) Whether or not *any* of these pieces could, or should, ever be performed again by someone else, was something that concerned me not at all when I created them. I am therefore very conscious that these texts, once written down, don't function at all as conventional playscripts are meant to. They are I suppose transcripts rather than, strictly speaking, scripts; annotated records of a particular speaking voice, sometimes indeed of a particular performance. They are all, to a greater or lesser degree, very much of their time and place, and not just in their emotional and political concerns; they are all site-specific, in that they were originally highly dependent for their effective-ness on the place and time where they were being performed. They all, even when they involve a very strong short-hand creation of a fictional character, assume that the

man performing them is doing so, somehow, in the first person. That said, I do know, from having seen it done, that some of the set-pieces speeches, like the description of a fraught night-time walk home in *A Vision Of Love Revealed In Sleep*, or the musings of Vince the barman from *Night After Night*, can make highly effective material quite out of context.

I often felt when I was writing these pieces that I was writing to an alter-ego's dictation; when I performed them, that I was being impelled from phrase to phrase by the sound of imagined voices coming from quite different, quite *other* parts of myself. I'd be delighted, then, if anyone else can hear these voices as clearly as I did.

This collection is respectfully dedicated to Robin Whitmore, to Bette Bourne, to Nicolas Bloomfield, and to the memory of H I H Regina Fong: four fellow gay London artists, and fellow-travellers, who performed alongside me in the final theatre version of *A Vision Of Love Revealed In Sleep*, and who each contributed hugely to the journey these pieces chart.

Neil Bartlett
2005

Where Is Love?
1987

This was one of the solo pieces that I regularly performed at AIDS benefits in the late 1980s. So far as I can remember, it first appeared at the Pegasus, a community theatre in East Oxford, in 1987. I also played it (amongst others) at the ICA on the night of its fiftieth anniversary, at the Royal Vauxhall Tavern, at the Barbican, at the Piccadilly Theatre (on the same bill as Lulu, I seem to recall), on BBC2 and to a memorably hard-to-handle audience of drunken lesbians at the Zap club in Brighton.

The piece gave voice to some of the intense and conflicting emotions which many of us who lived through the plague years in Thatcher's London felt. Exhilarating defiance; numbed pain; almost disabling anger. I had worked as a volunteer in the London office of International AIDS Day in 1986, so knew all about the practicalities of bucket-rattling; I also lived on the Isle of Dogs at the time, and so knew all about being abused on buses.

Perhaps because the physical threats to our bodies were so great, the 1980s were also intensely sexual times. I performed the piece shirtless, wearing boots, 501s, a black leather jacket and black leather gloves; sideburns, a moustache, greased hair, a can of beer and the inevitable Marlboro completed the picture. When the piece reached a certain temperature, the jacket invariably came off. The combination of this casually out-for-a-fuck image with an uncomfortably phrased and uncomfortably 'political' text was deliberate; so was my choice of intro music. As the slow fade-in of a single white spotlight revealed me standing smoking at a stand-up microphone, the impossibly pure treble voice of Keith Hampshire singing the tear-jerking 'Where Is Love?' from the original cast recording of Lionel Bart's *Oliver!* provided the oddest possible contrast with how I looked (and how I felt).

The monologue always began very quietly, as if I was checking the mike level. My voice never lost its deliberate self-control.

Where Is Love?

Can you hear me? Can you hear me? Can you hear me now? What have I gotta do to make you hear me; what've I gotta do to make you understand? What've I got to do to make you listen to me, 'cause it always seems to me…there ain't no charity these days. Can you hear me now? That's good, because I want you to hear what I'm saying. I want you to understand what I'm saying. I want to talk to you. I want to talk to you, but if you like, I could send you a letter. I could type it. I could send you a report, I could get somebody to type it, we have all the statistics right here. I could show you some photos, that way you'll know what it looks like. I could introduce you to some friends of mine, to some people that I know. Or, if you like, we could meet, just you and me. I could come to your office; or if you'd like you can come to my place. Or if you like we could just talk on the phone. Would it be better for you if I talked very quietly, or would you hear me better if I talked very loud? I could practise getting angry, if you like. Would it be better if I practised getting angry or if I practised not getting angry? Can you hear me now? How many of us do there have to be for you to hear me? Are there enough of us yet? Are there enough of us here? Are there enough people in this office? Do we have enough volunteers? Do we have enough people to man the phones? Do we have enough people for the phones, enough for the t-shirts, enough for the buckets, enough to count the money? If you like, I could fix it so there are fifteen thousand of us. Because you see I think it's very important that a lot of people get involved. I think everyone should get involved in this kind of fundraising effort. And as my contribution towards tonight's effort I should like to sing you a song.

I should like to raise your consciousness, I should like
to raise *my* consciousness, I should like to raise the roof
and I should like to raise some cash. And I should like to
dedicate this song to everyone here tonight, to all of you,
and to all of us, who are HIV positive. And I would like to
dedicate this song to all of us, and to all of you, who have
attended funerals this year; and to all of us who won't be
here next year; and I would like to dedicate this song to
all my friends and all my lovers and my dear friends and
my colleagues. And I would like to dedicate this song
to everyone here tonight who has been to bed with me.
And I would like to dedicate this song to everyone here
tonight who would like to go to bed with me. Anyone here
tonight who would like to take me home – I'm staying
with friends, but that's OK, we could make less noise than
usual…and I'd like to dedicate this song to everyone here
tonight who'd like to fuck me. Everyone here who'd like
to have safe sex with me. Everyone who would like to
have unsafe sex with me. And I'd like to dedicate this song
to anyone here tonight who'd like to tie me up; anyone
here tonight who'd like to get real dirty with me, anyone
who'd like to tell me about it, anyone who thinks they
have never been into that kind of thing but thinks that
maybe, with me, they could be. I'd like to dedicate this
song to anyone who fancies me just because I'm dressed
like this and I would like most especially to dedicate this
song to all those people who have in the last three months
verbally, physically or otherwise abused, assaulted and
humiliated me because I am a homosexual, and I would
most especially like to dedicate this song to the six men I
met on the number fifteen bus last Wednesday evening and
I would like to say, boys: this one is for you; boys, I would
like to give you, I would like to give you, I would like to

give all of you, I would like to give you – a piece of my
mind:
 I would like to give you – a helping hand
 I would like to give you a shot in the arm
 A shoulder to cry on
 I would like to give you…all of me.

 Why not? – take all of me;
 Can't you see, that I'm no good without you?
 Take these lips; I'll never use them;
 Take these arms, I want to lose them…;
 Your goodbye left me with eyes that cry;
 How can I go on dear, without you?
 You took the part, that once was my heart,
 So why not take all of me?
 All of me,
 Why not take all of me?
 Can't you see, I'm no good, without you;
 You took the best
 So why not take the rest…
 Oh
 Baby…
 Take All Of Me.

A Vision Of Love Revealed In Sleep (*Part One*) *1987*

Nearly twenty years later, *A Vision Of Love Revealed In Sleep* is still considered by some punters to be my trademark work. It's critical notoriety doubtless comes partly from the fact that I performed it entirely naked.

Its anger, and its determination to celebrate the beauty and daring of its then-forgotten subject's life and work, came from the time and place it was made in: London at the height of the first wave of the British AIDS epidemic. Playing my way through this piece, I felt as though I was fighting for my life.

Vision is a very rough text; at times, chaotic. In performance, it was often embellished by improvisation – the National Gallery sequence in particular was quite wild. Sometimes I had to incorporate the vivid reactions of the audience; a married couple in the front row in Glasgow argued audibly over whether my lingering enunciation of the word 'boy' was sufficiently revolting to oblige them to walk out (he left, she stayed); the entire audience, in a community centre in Loughborough, rose silently to its feet in response to my proposing a toast.

The piece is littered with quotations. The nineteenth century sources – Solomon's own work, Dickens – are given in the text. The contemporary ones were all taken from the newspapers and radio programmes that daily fuelled AIDS hysteria at the time. The phrase 'Don't Die of Ignorance', for those of you who weren't there at the time, was a slogan from a Government campaign of television adverts laughably supposed to promote AIDS awareness.

Although the words and structure were my responsibility, the piece as experienced by the audience was as much the creation of my collaborator all through the nearly six years that I performed it, the artist Robin Whitmore. For this, the first solo version of the piece, Robin turned the entire entrance hall of the Battersea Arts Centre, its two-storey Edwardian marble staircase included, into a hallucinogenic midnight-blue phantasmagoria. Using Solomon's

own late-career materials of chalk and cardboard, he covered every inch of the interior with a dreamy, star-spangled sky-scape, populated by flights of Solomon's swooning, muscular angels. When I performed it again a year later in a derelict warehouse in Shad Thames, in the shadow of London Bridge, he etched the ruined building's walls with a haunting series of scorched, charcoal-scrawled faces that cross-bred Solomon's dreaming Israelites with his own obsession with bruised and bleeding London boot-boys. He then threw the whole space into the realm of the visionary by covering walls, ceiling and floors with a truly astonishing Milky Way of stars, that myster-iously fluoresced in the darkness of the show's opening sequence. The ruined lobby of the building, where the disorientated audience congregated in the freezing cold before the show began, he kept exactly as he found it, littered with garbage and broken glass – but painted every inch of it gold, and lit it only with a flaming *menorah*.

A Vision Of Love Revealed In Sleep (*Part One*)

*A spectacle dedicated to the memory
of Mr Simeon Solomon*

As the audience enters the building they are met by crude bright light-ing, a solid wall of black drapery and a too-loud disco tape mixing Schoenberg's 'Verklärte Nacht' with Kate Bush. The music stops. Ushers, using torches, escort the audience, in small parties, to their seats. There is some confusion as they enter a dark, smoke-filled world of marble balustrades, stairways and balconies. The walls appear to be shining with stars. A litter of black plastic garbage bags. The audience is seated all around the space, huddled on the stairs and leaning over the balconies. What little light there is is blue. The silence is broken only by quiet fragments of birdsong.

A man is noticed gradually crossing the upper balcony. Eyes closed, he appears to be sleepwalking. He is naked, and clutching something to his breast, wrapped in a long, trailing length of dull scarlet silk. He has a flaming red beard and shoulder-length hair; his body is completely shaved and powdered – a marble statue, an artist's model, a painting.

He turns on a naked lightbulb, which burns dangerously close to his face. At once, the text begins.

What time is it?

Upon the waning of the night, at that time when the stars are pale and when dreams wrap us about more closely…

I had this dream…: I was dreaming, and when I woke up I could remember three things, and the first thing was

I sleep, but my heart waketh

And the second was

Many waters cannot quench love

And the third, and the third was

Until the day break and the shadows flee away.

And I fell to musing and pondering upon these things...

And then there came to me a vision, and behold, I was walking in a strange land that I knew not, and it was filled with a light I had not seen before, and I was dressed as if I was going on a journey. And I went forward with my eyes cast down upon the ground, dazed and wondering, and I felt just like one who sets out on a journey but who doesn't know where that journey is supposed to end. And I besought my spirit to make itself clearer to me, and to stand by me, and show me what it was that I was supposed to be looking for. Then the silence of the night was broken, and a faintness fell upon me, and for a short while I knew nothing, and then I looked up; and there was someone standing right next to me.

The scarlet silk slips, and using the lightbulb he shows the audience the picture he has been clutching to his breast.

This is a picture of Mr Simeon Solomon, born in London in 1840, in the nineteenth century. He died in 1905, in our century. He was short, fat, thin-legged, ugly, alcoholic, red-haired, bald, criminal, homosexual, Jewish...

He hangs the portrait carefully on a nail in the wall; he leans over and kisses it tenderly. He whispers something to it, so quietly that no one can hear what he is saying to Mr Solomon.

Mr Solomon earned his living as a painter, and this –

Switching off the lightbulb and showing the audience the whole of the space around him, filled with images from Solomon's paintings.

– this is one of his paintings. He also wrote a book; and this
–

Turning the pages of a slim volume.

– this is his book. He called it *A Vision Of Love Revealed In
Sleep*, and everything I say tonight is true, and everything
I say tonight is written here in this book, and this book
was written in 1871... And I turned to the one who stood
beside me in my dream, and I lifted up my eyes and gazed
upon him. And he looked full upon me, and he spake unto
me and he said – What are you staring at? And I said, I'm
sorry, I'm sorry – I don't know why I'm staring at you, it's
just something I do, sometimes I do that, I stare at strange
men – And I turned to the one who stood beside me in my
dream, and he looked full upon me, and he said, I know
whom thou seekest, he whom we go forth to find. He
only appears to those who grope in the waking darkness of
the world; in visions shall he be seen of thee many times
before his full light is shed upon thee, and thy spirit shall
be chastened and saddened by what it sees, but it shall not
utterly faint. Look upon me, and I will support thee, and in
thy need I will bear thee up. Come. And he took my hand,
and he led me along a dim sea at ebb, lying under the veil
of a mysterious twilight of dawn. I could see that his lips
trembled with the unuttered voices of the past, but he was
not crying. We went along, and then he stopped, and he
turned to me, he looked at me, and he said –

*He stops and looks at the picture of Mr Solomon, and then begins very
quietly to address questions to members of the audience.*

Can you tell me what he looked like?
Can you tell me anything about the kind of clothes he
wore?

Can you tell me what street he lived on – or the name
his mother used for him when he was little – you see, I
don't know. I don't know. I don't know. I used to know;
I used to know; I used to know but you see I don't know
any more, I'm sorry; I'm sorry, I can't help you – I wasn't
born round here you see. I'm sorry but I can't quite see
you, it's a bit dark in here, I can't quite make you out; I'm
sorry, I don't know why I'm following you, I don't know
why it's you I follow, it's just something I do sometimes, I
follow men; I get off the bus and I just follow someone – it
makes me late for work, I get into all kinds of trouble, I
don't know why I do it. I wasn't born round here you see,
I'm not from here. I was born in 1958. I have a friend who
was born in 1938. My grandmother had a sister, she was
a lesbian, we don't talk about her, she was born in 1897,
and the family lived in London then, South London, and
when she went up to the West End she might have seen
him, she could have told me what he looked like – but she
never told me anything. What I'm trying to say is, ladies
and gentlemen, is there anybody here who remembers the
nineteenth century?

Oh well, not to worry, there wasn't anyone in at the eight
o'clock show who did either. Excuse me –

*He takes a short break, welcomes any latecomers, fills them in, greets
any friends or particularly handsome strangers in the audience, drinks
from a bottle of beer, which he usually empties by the end of the even-
ing. Then he returns to turning the pages of the book…*

In 1869 Mr Simeon Solomon wrote his autobiography. It
is thirteen lines long, and entitled it: 'A History of Simeon
Solomon From the Cradle to the Grave'.

He was pampered. As an infant, he grew fractious. His
family had money. Everything was going to be alright.

Everything was going to be alright –

– is this a familiar story to anyone here tonight? At the age of sixteen young Simeon had already illustrated the Bible. His favourite book in the Bible was of course... The Song of Solomon.

As if in church, using the red silk drape to create a series of tableaux.

The Song of Songs which is Solomon's, beginning at the third chapter, the first verse, which is: I sleep, but my heart waketh.

> I am asleep, but my heart waketh.
> Listen, my Beloved is knocking –
> And he says:
> Open the door to me, my sister, my dearest;
> My love, my dove, my undefiled one; my head is drenched with dew, my locks with the moisture of the night.
> And she says:
> But I have stripped off my dress – do you want me to put it on again?
> I have washed my feet for the night – do you think I should get them dirty?
> And then he reaches out his hand –
> When my beloved slipped his fingers into the keyhole, my bowels stirred within me.
> When I rose up to greet my beloved there was myrrh dripping off my fingers –
> The liquid ran down over my fingers onto the doorhandle.
> I rose up, and opened up to my love;
> But my love had turned away and gone by.
> I sought him, but I could not find him;

I called to him, but he would not answer.

So I said: I'll get up, and I'll go out through the city at
night, through its streets and squares, seeking my true
love;

And I sought him on Poland Street, on Old Street and
in Berwick Street market –

But I could not find him;

And I called for him on Villiers Street and even on the
Earls Court Road, but still he would not answer me;

And the officers going the rounds of the city wall, they
met me, and surrounded me, and abused me, and they
stripped me of my cloak, and I said:

Officer, have you seen my lover anywhere?

And no sooner had they left me, than I found my true
love,

And I seized him,

And I would not let him go: and I took him home, to
my Mother's house,

And I said: Mother: Here He Is.

Wear me like a seal upon your heart
Like a ring upon your finger;
For Love is stronger than Death,
Passion, as cruel as the Grave.
Love burns up fiercer than any flame;
Many waters cannot quench Love,
And no flood can sweep it away.

Everything *is* going to be alright.
Everything is going to be alright.
Everything is going to be alright…

At the age of eighteen, he was hated by all of his family –
oh surely that can't be true boys and girls? Everybody's
mother loves them. And he had a sister, Rebecca, and she

was an artist too, and she was an alcoholic, and she never got married either, and she loved him –

At the age of eighteen he was hated by all of his family. They sent him away to France.

Unfortunately history does not record exactly what young Simeon did in France…but we do know that he returned to London in disgrace…

So they sent him away to Italy, to study Art – and in Italy Simeon had sex with one, two, three, four, five, six, seven, eight, nine, ten, eleven, twelve, *thirteen* Italian boys. Well, he was there for three months. He returned to London. *Everybody* was talking about Simeon's pictures… Simeon liked to paint boys…draped in silk. Boys dressed as women…boys, praying to God…and boys…with wings!! He returned to London in triumph – he knew everyone – anyone who was anyone – he knew de Morgan, Morris, Burgess, Swinburne, Pater, Rossetti – one night he made his entrance into a particularly aristocratic dinner party dressed in the flowing robes of a Hebrew prophet, reciting a hymn in a language which no one else there could possibly understand – and another night, just for fun, he ran around a house on Cheyne Walk stark naked…and screaming like a cat – Pater, Rossetti, Morris, Mrs Morris, Burne Jones, Alfred, Lord, Tennyson – Simeon Solomon was very unattractive; like me. Simeon Solomon had red hair. Like me. When he was a young man, he shaved off his beard to make himself more attractive to other young men, and this made him a very…bad…Jew; and when he was old he went bald and let his beard grow long and red and dirty and stinking and in fact he looked just like a dirty… old…Jew – everyone, anyone who was anyone, de Morgan, Morris, Rossetti, Swinburne – who was a sado-masochist,

Walter Pater – who was a homosexual, Gerard Manley
Hopkins – who liked to write poems about young men
dressed as soldiers, Lord Tennyson – who wrote a very
long poem about being in love with another man, Oscar
Browning – who was a teacher, and who liked to watch
thirteen-year-old boys being beaten, Edmund Gosse – who
wrote a whole book about being in love with another man,
and that man was his father – Rossetti, Burgess, Morris,
Alfred, Lord, Tennyson, Poet, Laureate; Lord Burne Jones,
Lady Burne Jones, all the Little Burne Joneses, all of whom
are now dead –

And of course Simeon knew a lot of other people, other
men, but we don't know anything about them, we don't
even know their names, we only know the names of two of
his lovers; of the rest we know nothing, nothing, not even
their names, *nothing* –

Ladies and Gentlemen, at this point in the performance,
I would like you all to consider the meaning of the
following sentence:

Don't Die of Ignorance.

Don't.

Don't.

Someone suggested that Simeon take a healthy walking
holiday in the Welsh mountains, and someone in the
house-party suggested that they get up early and climb
Mount Snowdon and Simeon said Oh really dear do you
think it will be open at that time in the morning? And
then when they got to the top he surveyed the view, he
gazed upon that panoramic vista and he said My God, it's
so quiet, one could imagine one was in the middle of the

country… And they said Oh Simeon, look down at that meadow starred with summer flowers, and he sighed and said Oh I wish I could paint flowers better, and they took him to see a famous Welsh waterfall, and he gazed upon its tumultuous waters, gazed up at its tumbling, tumultuous waters, and he said, Of course, you realise they turn this all off at night?, and then he looked down –

And I looked down –

And I looked down and I saw that the way before us lay as if starred with golden flowers, and grass lay under my feet; and I called on the one who stood by me in my dream to stand close by, and he stood by me and he whispered in my ear, It is well that thou hast looked upon the pleasure which is past, for now with greater ardour dost thou desire him whom we go forth to find. Canst thou bear to look forward?

And I looked forward, and I saw that the way before us grew thick with poppies, purple and red, and the air grew heavy with their odours, and I would fain have slept, and I said I'm lost –

I'm lost.

I'm lost.

– and he said: Close your eyes.

I said I can't see anything, and he said – *There he is, can't you see?* – and I said I can't see anything and then I looked again and I saw myself in the mirror, aged sixteen, and then I looked again and I saw this man – I'd never seen him before – and I looked up –

And lifting my eyes I beheld one whom I knew not seeking

shelter in a cleft in the rocks. The shame which had been done him made dim those thrones of Charity, his eyes, and as the wings of a dove, beaten against a wall, fall broken and bloodied, so his wings fell about his perfect body. His head was drenched with dew, his locks with the moisture of the night. The crown of flowers on his head was broken; he was wounded beyond all hope of healing, bound hand and foot, crushed with the burden of his so great tenderness. And I knew that he, in whose presence I now stood, was Love, dethroned and captive, bound and wounded, his wings broken and bleeding and torn. Now he came forth from his sheltering place, and as he went along the light about his head was blown into thin flames by the cruel breath of the sea; and I saw moving beside him there a crowd of all those who had brought him to this pass; and I could look no longer, for I saw in that company the image of myself. And I knew that the divine captive read my inmost thoughts, for there proceeded inaudibly from his lips the words, Thou hast wounded my Heart.

And I raised my eyes, and behold, the Vision of Love was gone, and for a long time I stood motionless. And then the one who stood by me in my dream lead me forth, and we went along the shore of the sea, and I saw that the way before us lay dark, and – and – I'm sorry but I really need to stop for a drink. So I stopped off for a drink, I went to this bar I go to, I walked into the bar, and when you go into the bar there's this mirror, you can see the men on the other side, and I walked in, and I saw this boy, he was just my type, and I knew that it was him I was looking for, and I went over to him, and I don't usually do this, I lay down at his feet, and I looked up at him, and he spoke to me, and he said, Thou hast no Pity on Thyself. And I never saw

him again.

And then I turned to the one beside me and he said, It is even so, thou hast no pity on thyself, thou hast essayed to kill Love, thou hast wounded his heart. Let us set forth, and I will show thee a history somewhat of his shame whom thou seekest; I will show thee a Vision of that which may yet be averted. Come.

So we went along, and there we came upon a crowd of men, all of whom bore different aspects, and I chose in that crowd one there to be myself. Some were mocking, some carried an air of scorn upon them and others of deceit; some feigned mourning, and others were not moved by what they saw. Then I approached, bent down with a great weight of sorrow, and through my tear-stained lashes I looked down and I saw the Vision of one lying there bound and wounded. The voice of his heart was as dead. His body lay untended, and no one had clothed him. His feet were tied. His white perfect body was flecked – here – and here – with blood. I knew that this too was Love, love betrayed, wounded, helpless, bruised, and I sank down and I cradled him in my arms and then I looked down and the Vision was gone – and I turned to the one who stood beside me and he said be not cast down; lay it as sign upon your heart, like a ring upon your finger. Come.

As this sequence continues and escalates, Nat King Cole singing 'For All We Know, We May Never Meet Again' plays quietly under the words...

And we went along, and I approached, bent down with a great weight of sorrow, and I looked down and through my tear-stained lashes I saw the vision of one who lay bound and wounded. His hands were tied, his body was naked,

no one had clothed him, no one had even moved the body out of the road, and I knew that this was Love wounded and bruised – he was bruised here and here and on the back of his left leg, over the kidneys and here on his face, and he was bleeding badly – so I got down on my hands and knees and tried to stop the bleeding and then the vision was gone; and I turned to the one who stood beside me and he said be not cast down, thou shalt not fail, for I will stand by thee. Come.

And so we went along, and I looked down, and I was back in the town that I grew up in, and I saw this man lying in the road, bleeding, and I got down, everyone was looking at us, and he said, it's too late, and I said it's alright I'll call someone, I'll call someone – but there was no phone, so I held him tight, just held onto him tight in order to keep him warm, I said all you have to do is just hold on till morning, and then the vision was gone and I turned to the one who stood by me and he said, Be not cast down, thou shalt not fail. Come.

So I approached, and I was weighed down, and I saw this man that I recognised, the face was different, but I recognised his body, and no one had clothed him, and he couldn't talk, and I just held onto him, and I sank down, and I turned to the one who stood by me and he said, Be not cast down; come.

So I approached, and I looked down, and it was someone I knew; someone I'd spent the night with; I recognised his body even though there was blood everywhere; and I wiped it away with my hands and then my hair and my jacket and I looked down and I said no, not him, not him, do you know how young he is –

And I tuned to the one who stood beside me and I said I

think we're running out of time; I don't think you can ask us to wait to be happy and I said and the sob burst forth from my lips up out of my heart and I said –

The music cuts.

– oh that the day would break and the shadows flee away indeed; I said, I don't think you know how much I want this night to end and the morning to come.

And the one beside me looked full upon me, and then he reached out his hand, and he put his finger on my lips.

A silence. Deadpan:

The other night I was walking home from the club it was about half past two I was on my own I couldn't hear anyone else on the street it was very quiet the buses stop at about twelve-fifteen or twelve-thirty and I couldn't afford a taxi and anyway I like to walk home because I think if you want to walk home on your own these days after dark then you just have to practise. It was about half past two I was on my own I couldn't hear anyone else and then I heard this car slowing down right beside me but I didn't stop I didn't look round because I think if you want to walk home on your own then you have to practise being not frightened. So I kept on walking because I wanted to get home and then I heard the car stopping right beside me so I thought OK let's get it over with so I stopped and I turned and I looked at the woman who was driving the car and she leant across the passenger seat she wound down the window and she said excuse me are you gay because if you are you're going to die you're going to get AIDS you wanker so I kept on walking because I wanted to get home and I think if you want to walk home on your own then you have to have practise not being frightened and then it

does get easier. I wanted to get home. On the way to where
I live there is a low wall on the right hand side and on the
wall I saw it said GAY and I thought Oh that's nice so I
stopped to read it and it said

GAY

G, A, Y

Got AIDS Yet?

and I thought that's terrible who would want to write a
thing like that I hope it's no one I know I hope it's not one
of my neighbours I hope it's not one of their children it
was about a quarter to three so I kept on walking because
I wanted to get home on the way to where I live there's
a wall on the left hand side and on the wall it said AIDS
I thought I won't stop to read it I've read it before it says
AIDS, Arse Injected Death Sentence and underneath that
it says One Man's Meat Is Another Man's Poison and
underneath that it says Queer Today, Gone Tomorrow so
I kept on walking, I wanted to get home. I live on the fifth
floor as I was walking up the stairs this man was going
down it was no one I know it wasn't one of my neighbours
it wasn't the new couple in number forty-six and as he
passed me he said under his breath you fucking – and so I
got home it was three o'clock in the morning and I closed
the door behind me. I closed the door behind me; and
I fixed myself dinner, because I think, when you live on
your own, you have to take really good care of yourself.

I fixed myself dinner. I laid the table because I think when
you do these things you should always do them with them
some style because then you do feel better. And I think you
should always have one of these in the house. (*He opens a
bottle of red wine, and lays a table.*) And while I was laying the
table I listened to the messages on my answering machine,
I don't know about you but it's always the first thing I do

when I get in and the first message said Hi, I'm fine, we
were just attacked by thirteen people, one of them tried to
tip a sack of garbage over my head could you call me over
the weekend; and the second message said Hi, I'm fine,
this man just tried to break my legs with a piece of metal
but it's OK I'm not seriously hurt, could you call me and I
was expecting a message from a third friend and he hadn't
called and I know it's stupid, I know, but I was worried
about him.

So I fixed myself dinner because I think when you live on
your own you have to take really good care of yourself.

And I think this helps. (*He drinks.*)

Do you know the feeling? (*Drinks.*)

And I would just like to say, I would just like to say to all
the gay people here tonight, I would just like to say to all of
you: Cheers!

And I would like to say, I would like to say to everyone
here tonight, to all of us, and boy, do I mean it: Cheers!

So it was three-fifteen and I fixed myself dinner and I
don't know why it is but at three-fifteen in the morning
there is only ever pasta in the cupboard, so I put the water
on to boil, and while the water was boiling I read the paper
because I hadn't had the chance to read it that day, and
the paper said why be afraid; why be afraid; why be afraid
to say it, sodomy and sleeping around are wrong, and
ninety per cent of homosexuals should be put in the gas
chamber and thank goodness that some people have made
their position quite clear and have come with standards of
conduct that mean that people don't have to be subjected
to this kind of thing and genital homosexual acts do fall

short of course of the Christian ideal and are to be met
with compassion and although the Pope has instructed
the Archbishop not to give communion to homosexuals
he has also said that when they are dying, when they are
dying, when they are dying he has sympathy for them in
his heart and I was moved by the spirit of God to say what
I have said I have no regrets I have never felt such peace
before in my heart well good for you I hope you sleep
well…so I stopped reading the paper, and I fixed myself
dinner, using fresh healthy ingredients just like you're
supposed to these days but I don't know if this happens to
you, I ended up chain-smoking. (*He smokes.*) It was three-
thirty, that time in the morning when you think I'll call
somebody oh no I can't. So I turned on the radio. And the
radio said don't get me wrong some of my best friends are
gay people but I think there are more you know gay places
than straight places these days and obviously it's a very
worrying situation because there are moral choices to be
made here on behalf of the community and the family and
the time has come to ban this homosexual propaganda in
the schools and on television these people have to realise
that their obnoxious sexual practices are a danger to our
society a very great one indeed and you might invite one
into your home without knowing it and that policeman
who said the gays are filthy well obviously I disagree with
him but I think it's good that he has the right to voice his
opinion and you have to realise that there are hundreds
and thousands of people in this country who do genuinely
hate gay people and their opinions have to be respected
– and I would just like to say that I am not making any of
this up – I think they should wear rubber gloves I mean
you wouldn't leave your child alone in the room with
a rabid dog would you there are homosexuals in this

department and I think its funding should be withdrawn – are there any teachers here tonight? – what we should see is deviance in the teaching profession being weeded out not these people being encouraged to force their prejudices and proclivities down our children's throats some people say they should all be lined up against a wall and I think that's a bit extreme OK but something has to be done to stamp out this terrible killer disease because I don't want to be walking down the street with my wife in one hand and my little baby daughter in the other hand and to see two blokes kissing and holding hands but you know that kind of thing is beginning to happen –

I don't know which papers you read and I don't know what radio programmes you listen to but I would just like to say again that I am not making a word of this up, what possible reason would I have to make a single word of this up –

– so I turned off the radio. I called up this friend of mine well he's not a friend really I just met him the once but you see he lives in a different country, and he said listen, does this kind of thing happen in London all the time and I said – I put the phone down on him and then I said oh no, I think only two people have been killed in London so far this year.★

He begins to raise a hammer slowly over the place-setting he has laid.

then I called my sister who I love dearly in an odd sort of way and she said Oh Neil it must be so terrible for you

then I tried to get to sleep I have this recurrent dream where I am in my bed and my Father is by the bed and he

★ *Note: this script was first performed in February 1987.*

is weeping because someone is forcing him to watch me die and I wake up screaming...

He smashes the crockery. Without pausing, he then cheerfully continues.

At ten past seven on the evening of February the eleventh 1873 Mr Simeon Solomon was in a public toilet just off Oxford Street with an unemployed stableman called Mr George Roberts. Aged Sixty. Not his usual type at all. Unfortunately history does not record exactly who was doing what to whom; we do not know if George was fucking Simeon or if Simeon was fucking George, or if George was sucking Simeon off, or if Simeon simply spat in the palm of his right hand and gave George a long and expert hand job, meanwhile offering him his left hand to bite so that the nearby shoppers would not be unduly disturbed by the sounds of their pleasure. They were arrested. Mr Solomon, who came from a good family, was fined one hundred pounds. Mr Roberts, who could read but not write – I'll just say that again; he could read, but not write – was sentenced to eighteen months in the house of correction. It quite possibly killed him.

Simeon Solomon never apologised for what he had done. He didn't hang his head in shame. He didn't even leave town.

Actually that isn't true. He did leave town; he left town for three months. History does not record what Simeon did for those three months. The next we hear of him, resurfaced in North Devon, where he began a new and glittering career giving public readings from the works of Mr Charles Dickens. Of course he did not say they were the works of Mr Charles Dickens, he claimed they were

his own; which seems to me to be Entirely Reasonable Behaviour! Unfortunately history does not record from exactly which of Mr Dickens' works Simeon chose to read but let us suppose, ladies and gentlemen, let us just suppose that he chose to illuminate with his thespian talents that masterpiece of Victorian sentimentality entitled *Little Dorrit*. Yes, *Little Dorrit*, ladies and gentlemen; and let us suppose that he chose to read from the fourth page of the third chapter of the first book of this massive tearjerker, let us suppose that as his *pièce de resistance* he chose to impersonate... Miss Wade.

Knotting the scarlet silk around him into a bustled skirt.

Miss Wade; who walked alone; Miss Wade, who had dark eyebrows; Miss Wade, who is in fact one of the great unloved lesbians of English Literature...; ladies and gentlemen, I ask you to imagine a heavy, faded, secondhand silk frock; a summer's night in France; a woman – at the end of her tether...

If I had been shut up in any place to pine and suffer I should always hate that place and wish to see it burnt to the ground; I know no more. I think that in our course through life we shall meet many strange people coming to meet us by many strange roads; and what it is set for them to do to us and what it is set for us to do to them shall be done. You may be sure that there are already men and women on the road who have their business to do with you, and they will do it; of a certainty they will do it. They may be coming hundreds and thousands of miles over the sea there; they may be close at hand now; they may be coming, from all you know and all you can do to prevent it, from the vile sweepings of this very town. Filthy brutes! leaving me here hungry, and thirsty, and tired,

leaving me here to starve for anything they care! Beasts – Devils – Wretches! It is nothing to you what is the matter with me. It doesn't matter…you are *not* sorry. You are glad. You know you are glad. I won't have patience! I will mind it. I'll run away, I'll do some mischief…I won't bear it; I can't bear it; I shall die if I try to bear it! Go away from me – go away from me! When my temper comes upon me I am mad. I know I might keep it off if only I tried hard enough and sometimes I think I do try hard enough and sometimes I don't and I won't. They all think I'm being well taken care of and have everything I need. Of course I love them dearly; no people could be kinder than they have been to a poor creature like me. Do go away. I am afraid of myself when I feel my temper coming, but I am much afraid of you… Go away – I won't; I won't; I won't – I won't – Oh God!!! –

Undressing.

God I feel so much better when I've done that bit.

You see Ladies and Gentlemen my problem is: I just can't control myself. D'you know what I mean? I mean I just can't control myself. I'm walking down the street and I think Oh Neil you're doing really well you're not crying; and then I realise that I'm biting my lip so hard that the blood is about to start trickling down my chin. And then I'm walking down the street and I think Oh you're doing really well you're not crying and then I realise that I am crying; and then I get on the bus and someone says Oh it smells as though someone in here has shit themselves; and then I knocked my beer over; and then I looked down and I saw that there was come on my hand; and then I looked down and I thought Oh I must have haemorrhaged because I was crying tears of blood that's what happens and

then I looked down and I had just come and this happens
to me sometimes I must have started crying because there
were tears splashing on his back and then I looked down
and there was shit all over my cock
 And then I looked down
 And I saw that I was bleeding
 And I looked down
 And I saw that the way before us grew pale beneath the
fading light of the stars, and the deep pools to the left of us
and to the right gave back their faint reflections, and this
whole night seemed to me to be a figure of my years gone
by, and I turned to the one who led me in my dream and
called on him to stand closer by me and I said
 Please, just put your arms around me…; I said:
 Before you go, d'you think you could tell me a story?

He returns to his book.

'A History Of Simeon Solomon From The Gutter To
The Grave.' Mr Solomon died of a massive heart attack,
induced by chronic alcoholism, in May 1905. 'Solomon
died a miserable alcoholic, alone and friendless, regretting
the vices that had destroyed his talent' … 'Have you heard
anything about that Miss Solomon? – I try not to talk
about it for the sake of the family. For my part, I hope I
never see him again' … 'He never painted again.'

Having got to the end of the book, he closes it.

It's not true. Simeon Solomon did not die young. He
did not crash his car. He did not fly into the side of a
mountain in a light aircraft. He did not die, sitting on
the toilet, from an overdose of barbiturates. He did not
stick his pistol in his mouth. He did not die, calling for a
priest, in a cheap hotel bedroom in France. He lived for

another thirty-two years, and for those thirty-two years
he drew, and he painted. He could rarely afford oils, so
he drew in chalk – red and blue chalks because they were
the cheapest – on pieces of paper and cardboard; and if
he had to he got down on his hands and his knees and he
worked as a pavement artist on the Brompton Road. And
he never, never, never, never, never apologised for what
he had done. And his friends came to him and they asked
him to come back, and he said no; and his family came
to him and asked him to come back and he said, no, my
behaviour has been perfectly disgraceful, I cannot possibly
ask you to forgive me: I shall try and come and see you for
tea next week – but I cannot make you a promise, because
you know whenever I make a promise, I have this terrible
need to break it – if you could just lend me eight or ten
pounds just now I should be extremely grateful…his sister
Rebecca was run down by a cab when drunk; his mother
died; and he supported himself selling matches and
bootlaces on the Mile End Road; and he slept in the gutter;
and his family got him put in the workhouse, and when at
the end of his life a journalist came to interview him and
said Oh Mr Solomon, it must be so terrible for you, living
in the workhouse, he said well actually I like it here; you
see, it's so central. In the winter, Lord Burne Jones invited
him to tea, and so he got up and he cleaned himself up
and he went to tea and he got blind drunk and they found
him in the kitchen, trying to get out of the window with
the kitchen silver. In the winter, his uncles bought him a
new suit of clothes – they said it was to keep him warm,
but of course it was to make him look respectable. And he
couldn't keep warm – not in the winter – not even wearing
all those clothes – so he'd go into the National Gallery –
because it was free – and he'd sit there for hours; staring at

the pictures…

For this next sequence he uses the hard, high, upper-class tones of the worst kind of National Gallery visitor.

…you know the other day I was just coming out, just coming out of Orange Street – I'd just been to the National Gallery actually, I don't know if you ever go – do you Sir? – you know you should, because it is free – oh you do, I am glad, because so many people these days you know they live all their lives in London and they never go and they should, they really should – well anyway I was just leaving the National Gallery, I'd been in room thirty-six actually, room thirty-six which is of course devoted to the works of the *Seicento*, the sixteenth century, featuring a particular favourite of mine, an altarpiece by Mr Jacopo Bassano, here we are, 'The Adoration of the Shepherds' – well, every nice boy adores a shepherd – and you will of course notice that there is a rather attractive young man here at the bottom left with his back to the camera, rather *attractive* – and I moved on, we move, we move on to room thirty-seven which is devoted to the works of Mr Leonardo da Vinci, Leonardo da Vinci oh yes and here we have that lovely little number 'The Virgin On The Rocks', there she is, completely on the rocks the poor darling; and as we gaze, as we *gaze* upon the faces of Mr da Vinci's angels we are of course reminded of that famous comment by that famous art critic Mr Walter Pater who said as we gaze upon the faces of Leonardo's angels, we ask ourselves the question: is that meant to be a boy or a girl well you tell me dear!! – and here we have the famous Leonardo cartoon, given to the nation by yer actual Princess Albert in the nineteenth century and here again we look at the faces in this picture and we notice the remarkable androg – the

androdge – the andro – the remarkably *homosexual* quality
of this picture, and now –

Suddenly dropping the voice, and producing a scrap of paper.

– I'd like to show you a picture from my private collection.
This is an early drawing by Simeon Solomon; it's called
'Love Amongst The Schoolboys'. I keep this pinned up
over my desk.

Back to the demented tour guide.

– and here in room ninety-four we have a splendid work
by Frederick Lord Leighton, Lord Leighton who of course
lived in Leighton House, tiles for days, just off Holland
Park Walk – good evening sir – and this picture is called
'The Desolation of Andromache' – there she is in blue in
the middle, completely desolate, the poor darling, I know
just how she feels – and everyone in this picture is *Greek*,
completely Greek – especially this young man here in the
lower left hand corner – and you can tell they're Greek
because they're *not wearing any clothes*. And now we come
to the end of today's tour, and I would like to end with a
particular favourite of mine, a particular favourite, this is
'The Martyrdom of Saint Sebastian', Saint Sebastian boys
and girls oh yes!! – and you will of course notice that he's
completely tied up, the saint. Completely tied up. And
you will notice I'm sure that the arrows there they are
penetrating his flesh, penetrating it! They are…*penetrating* it.
And I must say that personally I find this particular picture
deeply satisfying, deeply…in a religious sort of way…

And so I was leaving the National Gallery, leaving the
National Gallery and they have these wonderful revolving
doors on the Orange Street exit now and over the top it
says *One At A Time Please* – and I thought to myself – Yes!

Please!! – and I threw myself into those revolving doors, just threw myself, and I was just coming out onto Orange Street and I looked down – and I saw him.

I saw him.

I saw him; there he was on his hands and knees – and do you know I've never been able to walk past one of those pavement you know pavement artists without feeling obscurely guilty, I don't know what it is exactly, I suppose one always thinks it could be you, it could be me – well anyway, I said:

My God; my God I haven't seen you for years...

I said, Steve – this is my new boyfriend, Steve – and this is, this is...

No, I'm afraid we're out to dinner on Friday...

Well don't talk to me, I've never been arrested – do you know if you tried to chastise him for his behaviour he would simply burst into tears, and so well I gave him a fiver. I reached into my wallet and I gave him a fiver. I dropped it into his dirty hat and as I let it fall, I thought, well, there but for the grace of...

(*As it falls.*) ...and I would like you to know that this is a real fiver...and I often ask myself which of us is going to end up like that – I mean which of us is going to be as happy as that – as happy as he was...and then I looked up –

I looked up –

I looked up and I saw that the stars grew pale; and ever the voice of memory murmured in my ears; and this whole night seemed to me to be a figure of my years gone by...

Do you know I saw him; I saw Simeon Solomon. I met
him – well I never actually talked to him but I definitely
saw him. It wasn't very late, must have been about half
past eleven, I was going home, I was walking across the
Holborn Viaduct, and you know if you look south towards
Ludgate Circus, you're looking down the Farringdon
Road, I looked down and I saw him. He was walking very
slowly, very slowly because he was always drunk in those
days, and I couldn't hear what he was singing, and he
couldn't see me – and I don't know why I did this, there
was no one else there, but I ran to the railing at the side of
the road, I leant over, I reached out my hand to him, and
I began to shout at the top of my voice: (*Morphing into a
drunken impersonation of early Tina Turner.*) You know, once in
everybody's life, you've been hurt; and that ain't nothing
to be ashamed of, because that's just the way Life Is. But
when you've been hurt – …when you've been hurt; oh
ladies and gentlemen I should like to sing a little song for
you now, and this song is dedicated to anyone here tonight
who has ever been hurt, and don't lie to me, don't you lie
to me honey, I don't even know you; your mother hurt
you, your daddy hurt you and your lover hurt you, and
this song is dedicated to the woman who first sang it, Miss
Marie Lloyd. Miss Marie Lloyd who first sang it one hot
August night in 1886 –

*By now, with the aid of a pair of spike heels, a fright wig and a pair
of tattered velvet curtains, he has turned himself into the singer, beer
in hand and belting it out.*

– Miss Marie Lloyd who was known as the *Queen* of the
English Comediennes; Miss Lloyd, who always designed
her own frocks; Miss Lloyd who said every show I do,
every show I do, every performance I give, every fucking

performance I give is a Command Performance, by command of the Great… British…Public!!! Don't yer just love'em?

Sings, to the tune of Lloyd's 'Follow The Van':

> This Young Man, said 'Meet me here this evening,
> I can't stop now, because I'm working';
> He was staying with his sister, but he had a place to go to – He said:
> 'I'd like to get you naked, and tie you up and fuck you.'
> So I turned up, and I waited; I waited – it was raining;
> I didn't want to spend the night alone…
> Then I just stopped off for a few pints of lager –
> Now I can't find my way home!!

All together now:

> The Boy I love is up in the gallery,
> The Boy I Love is a-looking down at me –
> There he is – can't you see – he's waving at me…
>
> I always hold in 'aving it if you fancy it –
> If you fancy it, that's understood;
> I always hold in 'aving it if you fancy it –
> 'Cause a little of what you fancy does you good!!

Big finish, big choreographed bow; he tears off the drag and continues.

And I looked down at him and I said to myself
> This charming man;
> He could charm the money out of your wallet;
> He could charm the drink out of a bottle;
And even when he was sixty he could charm a boy down an alleyway and *yes*, he was lonely; *yes*, he was cold at night; *yes*, he smelt bad, *yes* he drank too much and *yes* he insulted each and every friend who had ever stood by him and I say:

that ain't nothing to be ashamed of, because that's just the way his life was; that's just the way Life is…and I looked down; I looked down and I saw the Vision of Love

And he was no longer wounded

No longer bleeding

And on his face hovered the half formed smile of a sleeping child;

And as I watched I knew, I knew that this was Love Imprisoned, Love Put Away; …and then, his lips parted with desire; his limbs stretched as if in readiness to depart, and his wings began to beat the morning air…; with one hand he cast aside the heavy mantle that restrained him; and I looked up – I looked up and I saw many there who I knew by name, many faces that were dear to me and many that I had seen in dreams, and one face in that company beloved of me above all the rest, and I knew that good things were about to happen – for when the sun rises on the outcast, who can tell; but I did not know… I did not know what was going to happen next. And I said:

That's it;
Now I can feel you.
Do it again.
A bit deeper now; now I can feel you.

And I turned to the one who stood beside me and I said, look, I know this is the first time we've talked about any of this – and he turned to me, and he said

You know –
But you don't know;
You know –
But you don't know;

You know –
But you don't know;
You know –
But you don't know what you want;

And he said:

I think you're ready now. Come.

And I was borne along. And I was borne up. And I saw the Vision of Love…

There arose before me the Vision of one sleeping. His arms were wound about his head. He was not crying, and his face shone. And he was naked. And I looked at him. And looked at him. And I can't tell you what he looked like; but as the priest places the flower-starred crown over the head of the bridegroom, and over the head of the bride, so Love was the light about us and the crown over our heads; and as the bridegroom kisses away the warm salt tears on the cheek of his beloved, as the thin, warm tears upon the face cheek of the sleeping bride are kissed away by him who knows that she is now wholly his and one with him, even so, the flame of Love fell upon my heart.

And then I looked up…

And the vision was gone – it was gone already. And the stars were fading, because it was morning already. It was half past four in the morning and I was going home; going home on my own. And I said, I said:

I'm going to keep on doing this, Until the day break, and the shadows flee away.

He opens an envelope.

Simeon Solomon sent me a letter. This is what he said to

me.

My Dear Boy,

Thank you so much for sending me your photograph.
You're not quite what I was expecting, But I think
you're very attractive. I can't help wishing that you
were just a year or two younger. I hear that London is
just the same these days, or worse. Please, try not to be
too frightened. You have to remember that none of us
knew what we were doing either. You just have to make
it all up as you go along. And tell me, are you on your
own? Are you alone?

I'm very sorry I can't be with you tonight,

Lots of love,

*He holds up the letter for the audience to read. It is a blank sheet of
paper. After twenty-five seconds, whatever light there is goes out.*

That's What Friends Are For
1988

Commissioned from an independent production company called Alterimage by Channel Four, the broadcast version of *That's What Friends Are For* (screened in July 1988), consisted of a single ten-minute tracking shot of myself walking down a long empty corridor in an abandoned Victorian workhouse in Peckham, wearing the regulation leather and denim and a number one crop, slowly snarling the text straight into the camera. The walls of the corridor were painted with pornographic images of snogging, haloed skinheads by Robin Whitmore; as the camera tracked down it, a dozen of our friends, acquaintances, lovers and pieces of current trade were revealed loitering in the shadows, wearing several kinds of variously butch and femme drag. Everyone, I remember, wore black for the shoot, without being asked to.

I later performed the piece live at several benefits. Funerals, benefits, handsome young men with cropped hair holding onto to each other for dear life; those were the days.

That's What Friends Are For

My Father said to me, he said, so, don't you ever worry
about growing old?

He said, don't you ever worry about growing old?

And I said, well Father what really worries me is whether
I'll ever get the chance to, I mean I sometimes wonder if
they're going to let us…

But if I do, if I do grow old, then it's going to be just fine;
it's going to be just fine, because I've got so many friends.

I've got so many friends.

I've got one to love me,
One to make love to me,
I've got one to lend me clothes, I've got one to take me
dancing:
I've got four to keep me warm at night,
I've got seven to pick me up when I'm down,
I've got seven to pick me up anyway,
I've got –

He said, but don't you ever get scared?

I said well when I get scared then I just call up one of my
friends.

He said, won't you be lonely?

I said, when I get lonely, I just call up my friends.

He said, but who's going to cook the dinner –

I said I'll cook the dinner – I'll invite some friends round;
you can bring the wine.

He said, who's going to take you to the hospital?

I said, well, I'll just call up one of my friends –

He said: you don't have a wife, you won't have any
children, you don't even drive a car –

And I said, it's going to be alright.
It's going to be alright,
Because I've got so many friends...

And I called up my first friend and he said I'll be right over
and I opened the door and he held out his hand and he
took me in his arms and he held me tight and he held on
to me, he held me together, he held me down, he laid me
down and he made love to me all...night...long.

Then I called up my second friend and he said, hello? and
I said, I'm sorry, I really don't know why I'm calling you,
it's three o'clock in the morning, and he said, it's OK I
was up anyway, I said yes but I don't know why I'm calling
you, and he said; it's OK, I can't sleep either. I don't know
anyone who can these days.

And then I called up my third friend, well he's not a friend
really I just met him down the pub, it's the same every
weekend, I say don't do this to yourself, don't do it, but
you know, what can you do, there you are, three o'clock in
the morning and you're walking home together – of course
we couldn't find a taxi, three o'clock, there she is, walking
down the middle of the bloody road, singing her head off,
and I said, what is she like?

She's like a child; she's like a sister; she's like a mother to
me that one; she's my best girl friend.

And I called up my fourth friend but he wasn't there so I
called up my fifth friend and I said I'm so sad; he said it
would be better to be angry; and I said I'm so sad; he said it
would be better to be angry; I said, but I'm so sad. He said,
you might feel better if you practised getting angry.

I called up my sixth friend and he said look I have no more
good advice to give you but I can give you this if you think
it will make you feel better, and he gave me a big bottle
of red wine and on the label he had written I Know Just
How You Feel, and that's just what you need sometimes,
someone who knows just exactly what it feels like...

So I called up my seventh friend

And my seventh friends lent me his books he lent me his
records, he cooked me dinner, he drove me home and he
put me to bed, he listened to my story, he heard me out, he
talked me out of it, he disagreed with me;
He knew what he was saying;
He knew what he was talking about;
He made five practical suggestions about how I might
improve my situation.

My eighth friend checks me for bruises; he calls me back
to make sure I'm alright and he lets me cry for as long as I
want to; and when we're walking down the street he never
lets go of my hand, not ever.

And my ninth friend said do you know, I haven't had this
much fun in *three years*...

And my tenth friend said Darling, I think I'm going to like
you with white hair...

And my Father said, but who's going to come to your
funeral?

> ...and I said

> ...well I said

> ...Father,

…That's What Friends Are For.

That's How Strong My Love Is
1989

This piece was also written for television, and was broadcast by Channel Four in November 1989. It was commissioned, in tandem with a new piece from the dance company DV8, to coincide with intense public and media interest in the dangerous 'new law' referred to in the third sequence of the text. This was the infamous 'Clause 28' of the 1988 Local Government Bill, which sought to institutionalize homophobia in English schools (and beyond) by banning any open or positive discussion of homosexual values or lifestyles. It remained on the statute books for fifteen years until finally repealed in 2004.

The monologue was filmed very simply, with me sitting on a battered old sofa, on which I was joined in each of the five sequences by a different grouping of significant others. In the first, by my choreographer colleague Leah Hausman and her three-year-old son, who was showing me their family photo-album; in the second, by my father, Trevor Bartlett; in the third, by a tangle of six handsome, chain-smoking, leather-jacketed gay men, all of them dear friends; in the fourth and fifth, by my then lover. These groupings were all static, with the exception of the occasional gentle kiss or clasping of hands; the text was spoken, quietly, either straight to camera, or in voice-over.

The title is stolen from Otis Redding; the voiceover under the credits re-works part of a famous poem by Bertolt Brecht, 'The World's One Hope'.

That's How Strong My Love Is

1: The Holy Family

Who's that a picture of then, Ben? Who's that in the picture?

And who's with Mummy?

That's a picture of Daddy. And that's Grandpa…and who's that there with Mummy and you? That's right, that's me Ben. That's me there and that's you with me. And who else is with me? Who's the man standing next to me? Do you remember his name. Do you remember meeting him? He's Neil's friend.

That's you when you were a baby.

When do you start school, Ben? When is somebody going to tell you that you shouldn't be with people like me?

What are you going to be like when you grow up?

What do you want to be?

Fade to black.

2: Father And Son

What did you want me to be when you grew up? You must have imagined it?

What did you think I'd be like? And how did you feel when I turned out the way I did? How did you feel the day I told you who I was? How did you feel when I introduced my lover to you?

And now, if someone came to you and said, *my* son has just

told me he's gay, I don't know what to do, I don't know what to say to him – what would your advice be? What stories would you tell him? Would you tell him about the first day, when we were both crying, when you said, I'd die for you. Or would you tell him about now, about the way things are now for the two of us?

I want people to know that I love you very much.

Fade to black.

3: So I'm In This Bar…

So I'm in this bar, right, and I said, where are you from? – and he's foreign, he's Dutch, he's from Amsterdam or something, and he doesn't understand what's going on – and he says, what is this new law you have here, please explain. And so I say, well, the idea is, you're not allowed to talk about it any more, I mean you're not supposed to be allowed to talk about it to *children*, and the idea is, you see, the idea is that if they don't hear about it when they're kids then they won't grow up gay. No one will talk about it; and we'll die out. There just won't be any more of us. I mean of course there will, there'll be thousands and thousands of gay people all over the world, but there won't be any here in *England*, you see, that's the idea.

And he said, but that's *insane*.

Fade to black.

4: Two Men, In Suits

…and I said, so what do you do for a living? – and he said, well, I'm a teacher actually.

So, anyway; two years later, we're in this bar, right, and I

can see he's looking at this boy down the other end of the bar, quite young, quite good-looking, and I said who's that then, and he said, oh, it's an ex-student of mine, I never thought I'd see him here. I said, didn't you know he was gay?

He said well I'd guessed he might be...

Did *he* know that *you* were gay?

He said well I think so, I mean, I don't hide it, but I suppose I don't talk much about it either...

Did this boy ever ask you for advice – I mean he's lucky, I wish I'd had a teacher I could have talked to when I was sixteen. I couldn't talk to my father, not when I was sixteen.

And he said, well no; he was in my class, but no, he never did come to me for advice.

So you didn't ever talk?

No, it didn't ever happen.

Did you talk to your colleagues about him?

No, you see, it is just very hard to make that happen...

They hold hands. Fade to black.

5: *Two Men, Shirtless*

What do you do when someone tries to hurt the one you love?

Tell me what to do: I don't know. Tell me.

This is my lover. He's a teacher. One night I was on my way to meet him; I was late. I was walking across Leicester

Square, and this man came up to me. He stood right in front of me, he was a big man, and he said, do you know what I'd like to do to you? I couldn't think what to do. I looked across the Square and I could see I was too far away from the nearest safe place to run, so I said, why don't you tell me? He said, I'd like to kill you.

And I thought: why would anyone want to kill someone?

I thought: I wonder what it feels like? Of all the things that one man could do to another with his hands – he wants to hit me.

I thought: why would you want to do that? And then I thought well it's not that strange. When you hate someone, you might well want to kill them. I mean you might want to kill them because you think they are one of those men who *bleep* other men. Because they are the kind of men who *bleep* other men. Because they're the kind of man who goes out all dressed up looking for other men to *bleep* with. The kind of man who'd like to *bleep* you. The kind of man who'd like to *bleep* you home, who'd like to *bleep* for the night, the kind of man who'd want to talk to you about *bleep*; the kind of man who'd lean over afterwards and whisper in your ear *bleeeeeeeeeeeeeep*.

It's not unreasonable. A lot of people feel like that a lot of the time – I mean you would feel like killing someone if they did a terrible thing to you. Or to someone you loved. Maybe your lover. Maybe your child – I mean just imagine that someone insulted the person that you loved. Committed a crime against the person that you loved. Imagine they locked the person you loved up in a room and threw away the key. If they reduced the person you loved to tears…well then you might want to kill them.

If they printed a story that wasn't fair; if they took away the things you need or the money that you need; if they took away the roof from over the head of the person that you loved so he had to sleep out in the street. Or if they withheld information that he needed, or if they damaged his body. Or if they made him cry with fear…then you might want to kill. It's not unreasonable. A lot of people feel like that a lot of the time.

But what would you do if they tried to hurt someone that you didn't love – someone you don't even know. Someone else's lover – somebody you've never even met, somebody whose name you don't know and whose face you can't see – somebody else's lover; *somebody else's child*. How would you feel if *they* were being hurt? What would you do *then*?

I want you to imagine that you're in a room – your living room perhaps – and you're with this person we've been talking about, the one who's been hurting people, the one responsible for other people's pain, the one who wants to hurt children – and tonight…you can do anything you like to them. There's nobody else here; the living-room door is shut, the front door is locked; and you can do anything you want. You can say anything you want. You can keep them there all night long if you want to. You can keep them there just as long as it takes. What would you say? What would you do? What would you do?

He kisses his lover on the neck. Fade to black.

6: An Overheard Fragment Of Conversation (*Voiceover Under Credits*)

…no but listen, if you see a young child picking up a knife, you just take away the knife, don't you? – you see a car coming, and there's a kid on the pavement, and you think

it's going to run out in front of the car, well you just grab
the kid, don't you, you don't have to be his mother, you
just grab the kid…

7: Caption At End Of Credits

THAT'S HOW STRONG MY LOVE IS

Fade to black.

Night After Night (*Part One*)
1993

In its final form, *Night After Night* was a fully (if modestly) staged musical comedy, with a pit-band, a leading man and leading lady, a chorus of dancing queens, countless costume changes and even a dream ballet sequence. But before it spread its luridly 1950s Technicolor wings on tour, it first appeared as a one-man show, with me playing all the roles, accompanied on the piano by Nicolas Bloomfield (composer of the later full-scale version) in the forty-seat Studio, upstairs at the Royal Court in London. This reconstructed script of that solo version can only hint at the contribution that Nic's almost-continuous underscoring and pointing of the words made to the piece. Even in its embryonic form, the piece was already dreaming of being a musical.

None of the words printed here as song-lyrics were ever actually sung; not least because I couldn't, and can't, sing. The character numbers were *almost* sung – spoken over music, *diseuse* style; when 'Trevor' did it, the effect was of someone quite *unconsciously* phrasing himself (seeing himself) as the leading man of a romantic 1950s musical.

I performed the piece in evening dress. The floor of the Royal Court Studio was covered in a litter of 1950s musical comedy albums, theatre programmes, wilting bouquets, spilt make-up, torn tickets. For the record, the essential idea of the piece, that I might literally impersonate my own father, Trevor Bartlett, was not just conceit, dramatic or otherwise, on my part. The fact that I looked, at 35, almost uncannily like the man who appears in my parent's wedding photos, was the mainspring of the piece.

This was the only one of my solo pieces that was created to be played in a theatre; but as you'll see, that was because it was *about* theatre – and specifically, about a kind of theatre which the Royal Court would normally never be seen dead housing. Hence the John Osborne jokes.

Night After Night (*Part One*)

NEIL and NICOLAS are identically dressed in Moss Bros 1950s black tie.

Houselights down.

Overture, during which NEIL sits quietly and listens, occasionally looking at his watch.

The Overture suspends –

NEIL: Good evening.

> Sometimes when people meet me for the first time, they say, do you know, I walked in, I saw you and I said to myself, Good heavens, it can't be, it can't possibly be him, it couldn't be. I thought it was Trevor you see. I thought you were your Father. D'you know, you look just like him.

NEIL puts on TREVOR's overcoat.

> Good evening.
> I was born in 1928.
> My name is Trevor Bartlett.

> I'm a bit early – I didn't want to be late you see. Usually we just go window shopping, because we're saving our money at the moment obviously – usually on a Thursday, late night shopping on Oxford Street –

> Recently married; four years ago almost exactly, spring of 1954.

> (*With secret pride.*) …No; not yet.

He keeps checking his watch.

> Sometimes you have to have a night out, don't you? –

(He was sixteen when the war ended, and then did national service – and you have to remember that coming up to town, seeing the West End with all its lights back on, the taxis, the reflections on the wet pavements – it was a real night out. I asked him what it was like once; and he told me, told me how he'd come in on the train from Clapham Junction and walk up, but she was working in Portman Square so could just walk there – they didn't get the bus unless they really had to; and they usually went to the Quality Inn because of the coffee, you could get unlimited coffee; and they'd go window shopping – and choose things – and promise themselves they'd have them, one day –)

– and so tonight I thought…; when she told me, I thought, well, I know we have to save up, but… No wonder I look so happy. Wouldn't you?

NICOLAS, who can't bear this any longer and clearly doesn't think the show should be about this sort of thing at all, interrupts him, in the voice of THE TICKET OFFICE QUEEN.

NICOLAS: Yes sir and how can I help you?

NEIL: Yes, do you have –

NICOLAS: Tickets available rear stalls upper circle and balcony.

NEIL: What price is the –

NICOLAS: Fifteen shillings twelve shillings or nine shillings and sixpence.

NEIL: Well could I have –

NICOLAS: Single?

Pause.

NEIL: (*With quiet pride.*) No.

Pause.

NICOLAS: That's two seats balcony nineteen shillings
evening performance, the early spring of 1958, the
house opens seven-thirty eight o'clock curtain and can I
help you madam?

*TREVOR puts two tickets into his wallet, and smiles. The music
sketches in a cluster of haunting chords – as if the romantic lead
was about to launch into an introspective song –*

NEIL: You know waiting like this, it reminds me of
other times, before…; when I was a child, of course,
the pantomime; and then when you're a young man
well it's the thing you do when you're a young man I
suppose, you come to the West End, up to Soho – it was
exciting –
And then when you start courting –
You meet a girl, you buy her dinner, you take her to a
show! –

Waiting…

Getting your hair cut – putting on a jacket –
Getting the train – getting a ticket, and –

With the piano; spoken as if quoting the lyrics of a song…

You don't know why you're waiting –
You just know there's something;
Know that there is something
That you've been waiting for;
Maybe just a dream –
A daydream, maybe –

You've so many nights ahead, so many shows to see...;
And it's exciting, waiting;
Waiting to meet...someone,
Wond'ring is this *the* one
That you've been waiting for;

Then you start to wonder
How it's gonna be –

Is this just somebody –
Just another show?
How will I tell –
Well –
Hell, I guess... I'll just know!!

And then, well, after you're first married you don't go
out so much because of course you're saving, you've
got the future to think of, but then when one night
you do arrange to meet up for a show like this, it's a
special occasion; and you find you're doing it all again
– checking your tie, straightening your jacket, getting
there on time, checking the tickets –

And once again you're waiting
For that special someone;
Sure this is the Someone
That you were waiting for;

Then you start to dream of
How it's gonna be –
We've got our whole lives ahead,
Just you wait and see –

And though you've found somebody,
Even though you're sure –
Still you find you're waiting

Waiting for that someone
Waiting till you see her
Walk In Through That Door!

He checks his watch, looks expectantly at the door –

(Do remember that this is my Father talking. It couldn't
be me. It couldn't be me feeling like that, it couldn't
be me talking about how I feel sometimes, because…
this is my Father talking; it's the early spring of 1958; I
haven't even been born yet.)

NICOLAS: (*On a microphone.*) This is your half-hour call,
gentlemen of the chorus, your half-hour call, thank
you.

*NEIL takes off TREVOR's overcoat, and via the action of hand-
ing over his coat at a cloakroom and getting a ticket for it, becomes
THE CLOAKROOM QUEEN. He slips a ring onto his
pinkie finger, lets a gold identity bracelet slip out from under one
cuff, and picks up a coathanger. NEIL's body language changes
each time he changes character in the show; but apart from that, all
the men in this story look the same, in their Moss Bros black tie.*

NEIL: You meet all kinds of people in this job.

Thank you Sir.

Thank you sir, yes that's right, eight o'clock.

It's a special occasion for a lot of people, isn't it, a show.
A night out. You have a drink and you get dressed up
and you sweep up those stairs and it's fantasy time.
And then on the other hand some of us get dressed
up like this because it's our job. It's what people
expect. I must say I feel a bit of a fool sometimes, on
a matinee day. It never seems quite right by daylight

does it all this sort of thing? Two by two up the stairs they come, and muggins here is left holding the coats, all dressed up and nowhere to go at half past three on a wet Wednesday afternoon. Well excuse me for introducing an uncharacteristic touch of social realism so early in your evening but that's life, isn't it, it isn't all Technicolor let me tell you. Some people have their big night out and they get exactly what they paid for and exactly what they were expecting, which is lovely. For some people. Get yourself all dressed up and up those stairs and swept away to fantasyland for a couple of hours. Well some people I know wouldn't mind living up there. Or at least stopping until breakfast time occasionally. Some people I know get dressed up and go out every single night of their lives hoping to get swept away.

Some people I know spend a great deal of their time waiting.

Some people of course get dressed up specially hoping that no one will notice. (*As if greeting a couple of gay customers.*) Good evening gentlemen. Both of the coats on the one hanger was it?

Like I said, all kinds of people.

And the funny thing is, they're all going to see the same show.

NICOLAS: Gentlemen of the chorus, the house will open in five minutes, in *five* minutes, please do not cross the stage.

NEIL becomes THE FRONT OF HOUSE MANAGER making his nightly speech to the ushers before he opens the house.

He is older, slightly military, closeted, and makes his speech as if he was an air steward giving emergency instructions.

NEIL: Gentlemen. Ladies. Before I open the house, may I remind you:

One: Every member of the theatre staff will be smartly dressed at all times.

Two: Everybody who comes here has paid for that experience and is therefore entitled to expect the appropriate courtesies from every member of the theatre staff at all times.

Three: Although for members of the staff this is something that occurs every night of the week except Sundays, for members of the public an evening at the theatre is a very special occasion, and it is therefore our job to ensure that their progress from street to auditorium is effected with an appropriate attention to detail, one that implies that all this is being done for their especial enjoyment.

Four: All members of the public are to be addressed as SirAndMadam at all times.

Five: In the unlikely event of it becoming necessary to remove from the theatre any undesirable elements I am to be informed at once. It is important to remember at all times that this building is intended to provide gratification for the general and respectable public and *not for anyone else*. Not for anyone else at all.

Six: The house will open promptly tonight at seven-thirty as on all other nights.

Thank you.

He opens the foyer by unhooking a silk rope from the stanchions, and begins to greet imaginary members of the public.

Good evening sir. Good evening madam. Good evening sir. *He welcomes all of the audience, pointedly missing out all the recognisably gay members of the audience.* Good evening madam. The house is now open. Sir?

TREVOR looks anxiously at his watch again, and asks –

What time does the curtain go –

Eight o'clock sir. The Dress Circle Bar Sir? The Dress Circle bar is at the top of the stairs.

Music, as NEIL unbuttons his jacket to reveal the maroon waistcoat of THE BARMAN. Throughout this next text he mixes his customer a (real) gin and tonic with ice and lemon.

Gin and Tonic sir? Certainly sir. And can I just say it's a lovely show, lovely, you'll love it. Lovely music. Quite swept away I was, but that's the thing with musicals I always think, promising you things you can't have, if you see what I mean. Anyway it's lovely just to have them for two and three quarter hours including interval, that's what I always say. One and six sir, thank you.

Pause; he returns the audience's stare.

Thirty-three. Four. Well none of us are getting any younger, are we? It does make you think – and thing is, once the curtain's gone up and the rush is off you've got time to, with this job. And you've got to think of the future, haven't you? Suicide, I think, for me. No, really, the thing is, I've been doing some reading up on…on…you know, the subject – four books I've got

through with this show already, that second act could
do with losing fifteen minutes if you want my opinion
– and according to them, it does seem that generally
suicide is the most likely outcome. Or your violent
death. Or prison of course but I don't really fancy that.
The thing is, apparently, being driven by abnormally
and irresistible urges to explore this difficult emotional
and social problem of contemporary society in the
strange and quite possibly tragic underworld of the
invert, haunted by the twin spectres of exposure
and humiliation, it's bound to happen, really. To any
doctor familiar with the psychiatric problems of the
Second World War or indeed any senior policeman
in Manchester, Bournemouth or any of our leading
provincial cities this pattern of behaviour comes
of course as no surprise; the increasingly desperate
search for affection, the inevitable disappointments,
the eventual hardening of the young man concerned,
rendered finally incapable of love by the scars of
bitterness, except perhaps for an affair with with a
former airman now married. Because as you know it
can't last, it never does. Four books I've got through
with just this show, it's a long second half as I
mentioned, and it never does, last, not in any of them.
Well it never does, does it? Not for us. I do know that
there are of course some characters of a more elevated
social position such as your doctors and lawyers who
people like me do occasionally meet at parties, who
don't talk as much as we do and they're not exactly well
what you'd call happy but they have come to terms
with *the situation*; well I'm afraid I don't think that's me,
really; I never really have been the leading man type,
I'm more of a character part really, and as somebody

said to me the other day you never really think about
whether the chorus are happy or not, do you? Not that
I'm saying that I haven't had, you know, friends, and
I've got my own flat now, as you know, but it doesn't
last, not for our kind, and eventually one is bound
to be forced inexorably into sordid furtive contacts
late at night in the darkened streets of London's West
End – well of course that is the thing with this job,
it does restrict the opportunities for what you might
call a normal social life in the evenings though I do
occasionally find the time before work to drop into a
dirty café off Shaftesbury Avenue where dozens of the
most blatant perverts meet openly calling each other
by girls' names or to visit pubs of a certain kind and
of course I'm not saying that we never get an evening
off, no, 'cause we do, usually I go to see one of the
other shows because you get to know a lot of other…
people, working in the theatre, musicals mostly I prefer
although I did go and see that lovely *Streetcar* with
Miss Leigh (anybody see it? No?), this boy I know
works there was able to get me a ticket actually and
I thought she was marvellous, marvellous, but there
you are again you see, the kindness of strangers, well I
do know exactly what she means and it's all very well
when you're younger, nobody wants to let their golden
moments pass them by, do they, you've got the rest of
your life to be on your own let's face it – and of course
her husband killed himself, didn't he. Well you would,
wouldn't you – no you would, if you found out like
that and in such into a very graphic way, (*lapsing into a
Tennessee Williams heroine*) coming suddenly into a room
that you think is empty – and it isn't, it isn't empty; it
has two people in it and Stanley, turn out that light!!!

– so that wasn't very uplifting for me, though as I say I did think she was marvellous, marvellous in that part I thought. No I think I am more of a musical person myself, something a bit more lavish is more me, I like all that, and of course the dancing. The boys...

He drifts off for a moment.

Well as I said I do like something to take me out of myself, I mean we could all do with a few more enchanted evenings couldn't we, and I know it's ridiculous but I sit there and the orchestra's tuning up and – and I'm off already...usually a bit younger is how I see myself, and I'm in a box at the opera, and very much in love, (*Celia Johnson in* Brief Encounter.) and there's suddenly nothing in the way, and I can see myself travelling to all the places I've always longed to see – Paris – Venice – leaning on the rail of some ship looking at the sea and the stars or standing on some tropical beach with the palm trees sighing above us... and then he puts his arm around me, and then...and then I'm back here pouring out a gin and tonic for some perfectly ordinary, respectable young man who has no idea at all what I'm feeling, and why should he, and suddenly I feel so utterly humiliated and defeated and so dreadfully, dreadfully shamed and I know you don't approve of women smoking in public and neither do I really but I had to have something to calm my nerves and I thought it might help.

He lights himself a cigarette. In his own voice:

I always have been quite...sensitive, you see... And so I expect I'll build up to it quite gradually; you know; leave my boyfriend for someone younger, get more and

more depressed, wear scarves at parties, all that sort
of thing. I have already started to drink heavily, which
does seem to be advised in most of the literature; gin –

And tonic was it Sir?

Ice?

And lemon?

He knocks back some of the gin. In NEIL's voice:

Cheers. One and six, eh? Still it was a long time ago.
I mean if you were born in 1958 you'd be, oh, at least
thirty-four by now.

You can get depressed on gin you know.

He drinks and smokes quietly while music plays. Interrupted by:

'Programmes on sale in the main foyer, sir.'

*NEIL finishes his drink, and becomes THE PROGRAMME
QUEEN; holding up a programme for sale – which he then leafs
through as he explains its contents. As the title of each number
is announced, NICOLAS quotes the tune for that number on
the piano.*

Programmes, programmes, get your programmes here…
containing a brief but informative introductory article
relating a brief history of this lovely theatre and of all
the happy shows which have made up that history, with
pictures of all the leading members of this particular
company looking happy or at the very least attractive,
and short biographies telling you everything…
everything about how happy they are to be appearing
in this show, no reference intended to any persons
either living or dead, any similarity of either name or

description is of course purely coincidental…and of course a full list of all the numbers in the show, so that it all comes as no surprise.

First, *Overture* – which is basically happy, although it does hint that things may get a little more dramatic in the second half, but as we know, life's like that; and not to worry, I'm sure we can all cope. The overture contains brief fragments from all the main tunes from the show, so that you do know more or less what is going to happen but most of all so that you do know that tonight at least you are going to get just what you were promised.

Which is what everybody wants.

Opening chorus: 'Shaftesbury Avenue by Night'; full Company, lots of chorus work, lots of arriving-on-time acting. This scene is just like real life, only choreographed. This is the scene that tells you that this is exactly the kind of show that you can take your girl to. Then:

'There You Are.' Aaah. This is the Boy Meets Girl scene. The scene in which all the married couples in the audience tenderly recall the scenes of their youth and courtship. Then:

'You're Just The Ticket For Me': this is the scene where the Comedy Boy meets the Comedy Girl – it's the same scene, but a bit brighter, and shorter. And they're a bit brighter. And shorter. This scene lets you know that this kind of thing could even happen to *you*.

Oh excuse me sir, I mean to the couple sitting next to you.

And then…

'Off We Go!!' – which the is Act One Finale, full company of course. Nice and loud, nice and big, makes you think that perhaps you don't quite know what is going to happen next in life, so that you'll want to come back in for the second half…well actually it makes you think that you do know exactly what is going to happen next in life but just don't know if it is going to happen to you just yet. Which is what this show's all about really.

There will be one Interval of Twenty Minutes.

…and then to get us in the mood for the second half, 'You Wonder Why You're Waiting'. This is the big tune in the show, really; this is the number you've all been expecting.

He isn't there…

And the lights go down

And then all the chorus boys or whoever stand around at the back, and one of them says

'Are you alright?'

and she says:

'Oh yes – sure; I think I'll…well I think I'll just sit quietly here for a while and…sing…'

NICOLAS plays the tune of 'You Wonder Why You're Waiting', which ends by modulating into some distinctly ominous chords;

…ah! The same, Later That Evening: This is the scene which hints at the darker side of the current social situation; the lighting gets very dramatic. Of course

this scene does introduce a note of redeeming social
interest into the whole affair, which may reassure those
audience members who thought that perhaps this
whole show was a gratuitous entertainment, was just an
exercise in futile glamour intended to cheer us up and
keep us all going and therefore wasn't about…real life.
And then of course you get the Dream Ballet; which in
this show is called –

'Not Here, Not Now.' In this show the ballet takes
place in a sort of mixture of Scotland, the Pacific,
Oklahoma, Broadway, Siam, Somewhere and Heaven.
Anyway; there's lots of room for dancing, and for
everybody to do things that could happen or should
happen or might happen. And so you see although this
scene ought to be confusing, it isn't; because everybody
knows that this is the one scene in the show which is
like real life. It's just that it's real life…in the future.

This being the Act Two production number it does
of course provide an opportunity for some of the
gentlemen of the chorus to remove their shirts which
is lovely for everyone but especially for you and for you
sir, where else in town can you get that for the price
of a theatre ticket, and in public too, but not to worry;
nobody will notice. Nobody else but you thinks that's
real life. Nobody else but you thinks that that's what
this show is really about…and then:

'You Wonder Why You're Waiting' (reprise), and in this
scene either he's gone, and she says she'll love him for
ever, which is wonderful, or, he's suddenly there at last,
and they both say they'll love each other for ever, which
is wonderful; either way, they really love each other,
and that's what really matters; that's what this show is
about –

and that is what this show is about, actually –

And the lights go down,
And whatever has happened,
He's there, and the chorus boys or whoever else was on
go off or at least just stand around quietly
And watch
And he puts his strong arms around her…
(Sometimes she just imagines this is happening)
and
they hold hands
and
…he looks just like my Father.

– and the boys in the chorus all know that the big duet
is coming, because they've all done this show before,
it's been running for months now, it's not as if this is
the first night that this has happened –

– and the band all know that the big duet is coming
because the conductor raises his baton

– and you all know it's coming because you've seen
shows like this before

and because life's like that

and because it's in the programme

but still, when just before the duet starts,

he puts his strong arms around her,

and they hold hands, and then he says –

…you know when he does that bit I believe every word.
Every night. I slip in and stand at the back of the stalls
in the dark and usually, I cry – which is stupid; because

he's not singing to me, is he?
He couldn't possibly be singing to me, could he.
It couldn't be me –
Couldn't be me he's got his strong arms around, and
She couldn't possibly be singing for me
Couldn't possibly be singing about how I feel
sometimes
And those boys standing around at the back when the
lights go down, well they've got to just stand and watch
because it's not their number is it.
It couldn't be.

Then you get your grand finale. That'll be one shilling
thank you sir.

*THE PROGRAMME SELLER hands over his programme
to TREVOR, who gives him the shilling, and then reads the
programme, smiling and laughing, while the music plays the big
tune from the show. He hums along, and even joins in with a few
of his own lyrics for the last lines –*

…You can just imagine
How it's gonna be…
There will be a song for us, just you wait and see –
'Cause when you're with somebody, it's
Not just another show –
Ev'ry Song is Your Song –

How do you know –
Well some things, you just –

The music is suddenly broken by:

'This is your five minute call, Gentlemen of the
Chorus, your five minute call, five minutes thank you.'

TREVOR becomes THE USHER. He is eager to get the punters

in, and, well, cross.

Could you have your tickets ready please? If you could
have your tickets ready please. Thank you. If you could,
thank you. Thank you sir. Have your tickets ready
please. Second aisle on the right thank you sir. If you
could, that would be a great help, alright then *third* aisle,
thank you.

*...This text continues ad lib as THE USHER, becoming more
and more flustered as he tears tickets and looking anxiously at his
watch as curtain-up approaches, switches into TREVOR looking
anxiously at his watch and getting increasingly agitated because
SHE isn't here yet; and then back into the USHER and then
back into TREVOR and so on; this complicated double act leads to
the USHER's body language becoming increasingly queeny, until
she finally gives the whole thing up in exasperation and declares:*

Yes, alright. I am. I AM. Well if they would (second
aisle on the right thank you) insist on giving me the
one job here that involves (inside, madam) constant
wrist (eight minutes past ten madam second aisle on
the left *If you could have your tickets ready please*) what can
they expect frankly. Now I know that some of you are
thinking (*Tears ticket.*) that this is all a bit much, that this
is all getting a little bit (*Tears ticket.*) excessive, a little bit
not like real life I mean there's no need to overstate
the case is there dear I mean when you go to the theatre
you don't want it shoved in your face, do you, I mean
social realism is all very well if that's the sort of thing
you fancy of an evening but I do have to say that this
is exactly the sort of thing that I find offensive in some
people's behaviour I mean I really think there is no
need to flaunt one's sexual disabilities in the face of the
general and as Mr John Osborne so rightly said (and

on the stage of this very building would you mind),
Mr John Osborne ladies and gentlemen – *Look Back In
Anger*, dear – did you see it, lovely title, I thought; *Look
Back In Anger*. Oh yes – Mr John Osborne ladies and
gentlemen and I quote (*Having produced a copy of* Look
Back In Anger, *he turns to the relevant page, and does so.*) 'I
don't care which way he likes his meat. He's like a man
with a strawberry birthmark – keeps on thrusting it in
your face.' Thrusting it. Exactly. I mean we all know
there are a lot of gay people working in the theatre,
there always have been and there always will, but it's
not as if they're actually running the building, *is it*?

Is it?

I mean if they were, I'm sure all these people wouldn't
be here every night, would they. I mean, the general
public.

I mean anyone might think watching this that someone
was trying to give the impression that the people
who're organising your nights out for you are all, you
know… theatrical.

The very idea.

I mean; some of us are and some of us aren't.

The thing is…
You can't tell.
Can you?

Music; as a patter song:

The one who takes your ticket;
The one who poured your drink;
The one who stands there smiling – well he's not what

you might think;
The smart one selling programmes – oh he surely
couldn't be;
The two who're right behind you but that you don't
even see;
Those three who seems to, well, stand out –
The four who you're not sure about –
Look surely they can't all be – gee! –
How can you tell –
Well,
You tell me…

(*With a microphone, like a reporter, spoken over a constant
cheerful vamp.*) Ladies and Gentlemen; How *Can* You
Tell? As you will have gathered, an evening spent
here in the heart of London's West End offers an
ideal opportunity to continue our investigations into
this most serious of issues. And if I may take the
opportunities of introducing our interviewees this
week, who are:

The Semi Obvious (*He indicates NICOLAS.*)
The Frankly Unacceptable (*Briefly becoming THE
BARMAN.*)
The Tip of the Iceberg (*THE CLOAKROOM
QUEEN.*)
The Cruel Hand of Fate (*THE USHER.*)
The 'Oh No I Don't Think So He Looks So Very
Smart in That Dinner Jacket' (*THE FRONT OF
HOUSE MANAGER.*)
…and perhaps perhaps the most interesting case that
we have here tonight, the 'The Strange Thing About
Him Is, He Looks Just Like His Father…'

This verse in a 'Kiss Me Kate' American accent.

The questions that arises here
Is what exactly makes it clear;
One guy's a guardsman, one's a peer –
So how'd'ya tell which one's the Qu...ite
Often as I'm sure you've seen
It's what they wear, or where they've been
That makes you think –
Know what I mean? –
But are you sure that guy's a Qu–

–estion One: 'Can I tell from the way he dresses?'
Well, as we all know, modern fashions can be cruelly
deceptive. Any man who is more than usually well-
dressed is of course open to justifiable suspicion, but,
for instance, in these particular cases, an evening in
the theatre is traditionally associated with dressing
up in the foyer just as much as behind the footlights
– and one dinner jacket, after all, does look much
like another...some details of personal appearance
do however remain reliable indicators: make-up; the
tell-tale pink and yellowgold Cartier identity bracelet;
the so-called 'pinkie'; the hair which is rather too
conspicuously...Tony Curtis...; and if you're still not
sure, the body itself may of course yield some clues;
watch out for that 'self-pitying' mouth, or of course
for those characteristically 'hard yet shallow' eyes. An
inability to whistle is not, contrary to poular belief, a
reliable indicator; trolling up the Haymarket whistling
'What's the good of wond'ring if he's good or if he's
bad' is however a dead giveaway... And, finally, should
an examination of the exterior prove inconclusive, then
it is always advisable to acquaint yourself with The
Interior. Peach mirror lining the (well-stocked) drinks
cabinet...a fitted Pearl Grey Axminster... Tassels...

Recordings of Musical Comedies…

You can be sure he's pretty chancy
If he puts on 'Shall We Dance'; he
Serves you up with something fancy –
Does that mean that he's a Na…ow
They can't help it – they're not crooks;
So some guy likes to sew, he cooks –
You read about this stuff in books –
Heck, should you judge on how he –

– Looks can provide a guide to superficial character
traits; but what about The Man Within?…

Question Two: 'How Does He See Himself'; and:
Question Three; 'What about The Future'. We put
these questions to our panel of informants… Sir?

*Using the microphone to be both the interviewer and interviewer,
he talks to:*

The Box Office Queen
What I always say is, life is very simple, why complicate
it, live and let live that's what I say and I think we've
all got a right to our own fair share of happiness.
For personal reasons I intend to wait until after the
Wolfenden report of 1967 before becoming, you know,
happy. Not long now.

And what about you, sir? The future?

The Cloakroom Queen
Could I just say that I'm really looking forward to the
1980s? I know that thirty years may seem like a long
time to wait to some people, but apparently there will
be a lot more places to meet people then, bars and cafés
and such, places to meet, which is something to look

forward to, isn't it?

And what about our friend behind the bar here? How do you see the future sir?

The Barman
Well, as I said earlier, suicide I think it has to be, eventually. Either that or a series of madly unlucky and unfulfilled relationships with ex-members of the armed forces, one brief spell of doomed happiness with an older gentleman on the Sussex coast near Brighton and then the bitter twilight years. I'm not giving up this job though. Sorry, but you're not getting rid of me. There's plenty more where I came from, oh yes. And it's no good looking behind you dear because we're already bloody there – no good keeping your back to the bloody wall because it was probably a friend of mine decorated it –

He cuts him off before he gets even more excited.

Sir?

The Front Of House Manager
I intend to carry on being violently unhappy and then later either come out in the course of a television documentary or just sit around telling young people that it was all a lot more fun back in the bad old days. And in answer to your first question, yes, I do think we do all look a bit the same. Look the same as other people, I mean. Just a bit more…tense.

'Course if a guy is wearing lipstick,
Calls you Mary – likes to kiss – stick –
–s on a dress – be
Realistic;

Clearly he is the Artistic
Type, who makes amusing hats, or
Does up other people's flats or
Has (*Suggestively.*) 'my own studio': you
Know what that's for –
You can tell what side *he* bats –

Four: 'Is Choice of Occupation a reliable guide?'
The subjects of our enquiry are of course as is well
known adept at passing themselves off as perfectly
respectable and useful member of society; however,
certain professions may provide a clue. Working on or
indeed anywhere near the stage is, for instance, never
a good sign… And, of course, as recent surveys have
shown, most, though by no means all, of these men are
unmarried.

He passes the mic to:

The Cloak Room Queen
I'm single.

The Box Office Queen
(*Showing his ringless hands.*)
Single.
Currently…

And you sir are you married?

House Manager
(*Reluctantly, after clearing his throat.*)
I'm a bachelor.
(*With trepidation.*)
And what about you Sir?

The Barman
My name is Vince, and I'm a theatre barman in the

West End of London. Of course you get to see a lot
of the shows, and lots of the boys who are in the
shows – well I say lots, quite frankly some of the last
night parties can get very Sunday Night at the London
Palladium if you know what I mean, people would be
shocked if they knew –

Thank you, Sir; what we wanted to know was, are you
single?

Why, who's asking??

Interviewer
So there you have it! That concludes our survey
tonight, 'Can You Tell?' Well…out here in the front
of house area, as the general public prepare to move
into the theatre, that home of dreams, all anticipating
a terrific show, it looks as though all will be just as it
should be as they take their seats tonight, all except

Just possibly

That third boy on the left during the opening chorus.
The one wearing…evening dress.

His face suspiciously unlined
His movements just a bit refined
The whole effect
Just too…*designed* –
Could he be, well, that way inclined?

Lined up and dancing, just for you –
P-reening, prancing, in full view
He jumps for joy –
Like lovers do;
What does that mean, if he's one too?

Music slows down to an alrming vamp for the final 'chorus'.

> To end, here's one to vex you all:
> A question, to perplex you all:
> He may be short –
> He may be tall –
> But
> is
> he
> ho-mo-sex-u –

The number is cut off by the sound of the five minute bell.

TREVOR looks anxiously at his watch.

The three minute bell.

TREVOR checks his tickets and his programme.

The Usher
If you could hurry along now and if you could have your tickets ready please…

The two minute bell.

Trevor
She said she'd meet me –

The Front Of House Manager
If you could make your way upstairs now sir, the show is about to start –

The final bell.

NICOLAS: (*On the microphone.*) Foyer Clear. Standby everybody.

The Barman
(*To the tune of 'You're Just in Love' from* Call Me Madam.)
NEIL: I hear music but she isn't here… A drink for the

interval Sir? Just the One?

A long pause. TREVOR is left alone in the empty foyer.

Music – at first, an introspective reprise of the 'Waiting' theme – but developing into a series of threatening interruptions as TREVOR's monologue, with its catalogue of quotations from famous musical comedy lyrics, each phrased more or less exactly as a spoken version of the originally sung lyric, becomes increasingly pressured.

Trevor

Waiting…
No use getting anxious…
Maybe there was something –
Sure, there must be something…

You do start to think,
What could it be,
P'rhaps she forgot it was eight, we'll just wait and see –

It's just another show –
Still if we miss the opening number,
That'll hardly matter –

It's in the programme. And it's pretty predictable what the plot will be – and there's bound to be a reprise later. I mean, you always come out of one of these shows feeling better, don't you? They always end up together one way or another. There's always that song where they say they really love each other, and that's all that matters; and the lights go down and he puts his strong arms around her, they hold hands, you hold her hand in the dark – and they've got their whole future to think of – they've got their whole life ahead of them – they're just starting out – just like in all these shows. And you know, you *know* that's how it is. You meet your girl,

you buy her dinner, you take her to a show... You're
on the town, with the girl that you married, and they
say that falling in love is wonderful... I should say...
well, I should say, we had an old-fashioned wedding;
I vowed to love her forever, from this day on, for the
rest of your life, for as long as you live, nothing else but
you, ever, out of my dreams and into my arms, blest in
the old-fashioned way... he ain't even been born yet,
but I can see just exactly how it's gonna be...well, the
dreams of ev'ry other dad; the first year we're married,
we'll have one little kid...my boy... I bet he'll turn out
to be the spitting image of his dad, and she won't make
a sissy out of him, not my boy, he'll look a lot like me,
the spitting image, well –

You've got to have a dream;
A dream worth a-keepin';
Out of my dreams and into...

And night after night, as strange as it seems, this song
will echo in your dreams; until you find your dream;
one dream in your heart; you got to have a dream, if
you don't have a dream, how you gonna have...?

Maybe tonight.
Hold my hand, and I'll take you there...

One final long and unsettlingly loud bell.

The Queens
I really must ask you to take your seat now sir...
Yes sir I will keep her ticket for her here sir...
If you could take your seat now sir straight up the stairs
if you could sir...
Ticket please thank you second aisle...

NEIL/NICOLAS: Mind how you go in the dark.

NICOLAS: Chorus to the stage please, chorus to the stage. Overture and beginners, thank you.

Silence. Darkness. As the piano delicately picks out the overture, the lights come gently up on NEIL sitting with his back to the audience, surrounded by the debris of a backstage dressing room, touching up his make-up in a mirror. He is now

The Chorus Boy

NEIL: (*To himself in the mirror.*) Good Evening. (*Via the mirror, to the audience, while making up.*) I always like to get in a bit early.

I like the opening number in this one. Evening dress always suits me. Has a sort of 'Shaftesbury Avenue with all the lights coming on' feeling, they do this effect with the coloured lights reflected off the pavements, lovely…then there we are: discovered. On the town, busy crowds…each boy has a partner, and the idea is you're courting, you're waiting to meet your girl after work, you're taking her to see a show, checking your jacket, getting your tickets, all that business… I always like the opening number actually. I know it's just there to get them all going but it gets us going too. You get your last call, you can hear them all out there on the other side of that curtain, the lights go down, you're waiting, the curtain rises…and then there we'll be. On Shaftesbury Avenue. Doing all the things you mustn't ever do, kicking and singing and looking lovely, the whole lot of you all together in a gang like that, all in public – and no one's going to shout out you can't do that, who do you think you are? I mean they've paid, haven't they.

And it's exciting…waiting.

He stands up, and checks his jacket – just as TREVOR did; as if the curtain was about to rise. Under his breath:

In place…
On time…
Warmed up; made up; dressed up;
Chin up.
Shoulders Down.
Arms Out.
Eyes Bright!!

Building up to the moment the curtain rises:

I know this routine backwards…
I know every step I'm taking…
And when people see me…

(He breaks into NEIL.) When people see me, they say Oh good heavens I thought it was him. You look just like he did.

I even move like he did. My chin, arms and eyes are his; my chest, here, and my ribs here. My stomach. My hair grows like his does. And on my body. I hold my shoulders like his. This, is my Father's body; and I can tell you at what age and therefore in what year my hair will, like his, start to turn grey. Where the lines on my face will be. People do say to me, you look just like him. You look just like your father's son.

A brief, electric suspension; then the music of the overture sweeps in, portraying 'her' arrival and the opening of the show. This music underscores the whole of the last speech, climaxing grandly on the title phrase, and then ending the piece with the same sequence of ringing, mysterious chords that opened it.

Yes madam – he left your ticket for you madam;
Curtain just going up madam –
Straight to the top of the stairs madam –
Second aisle and on your left –

Mind how you go in the dark...

And then she says, 'Oh darling sorry I'm late', and
then there's that bit where he says it doesn't matter, it
doesn't matter just so long as you're here. And then the
lights are about to go down – *standby house* – and he puts
his arm around her – *go houselights, standby curtain* – and
they sit there in the dark, and they hold hands – *curtain
going up – good luck everybody!!* –

What will be the changes? You never can imagine; he
never could have imagined who these arms of mine
would hold, what this body of mine would do night
after night; the others I'd hold, both alive and dead; the
sweat; the love made; the dreams I would have at night,
the streets I can't walk down, the words I hear said out
loud; he never could imagine that this would be the
future, that these songs would be our songs – but when
the lights go down and you hold hands, you must, you
must imagine, tonight and tomorrow night and every
night of our lives, because that's what we sit in the dark
for, that's why we go out at night; because the future
has still to happen, the show has still to start; and my
Father is going to have a son; and it will happen, the
curtain will rise night after night after night – so hold
my hand, and I'll take you there; hold my hand in the
dark; hold it; day after day; year after year; night after
night after night.

The Seven Sacraments
Of Nicolas Poussin
1998

This piece was performed (for seven nights only) in a small lecture theatre in the bowels of the London Hospital in Whitechapel. This room contained nothing but the paraphernalia necessary for lecturing: blackboards, a lectern, a slide projector, a screen, a desk. It also contained a silent, lab-coated assistant, Robin Whitmore, who each night, while I lectured, created and then erased a sequence of seven chalk drawings, reworking anatomical motifs from each of the Poussin paintings in turn in the style of medical textbook diagrams. Slides of each of the seven paintings were also projected – sometimes onto the screen, sometimes onto my body.

The passages of text printed in **bold** are quotations from either *The Book of Common Prayer*, or the sermons of John Donne.

The Poussin paintings are on permanent display in the National Gallery of Scotland. Since the act of looking at them is an essential part of the action of the piece, having a set of postcard reproductions in front of you might help to make sense of my meditation on their sombre beauty and rigour.

This text is dedicated to my mother,
Pamela Doreen Bartlett

The Seven Sacraments Of Nicolas Poussin

The audience is led down neon-lit corridors into what feel like the bowels of the building: a small lecture theatre, situated, as it happens, close to both the terminal care wards and the maternity wing of the London Hospital.

Inside the small, darkened lecture theatre, there is the barely audible, non-stop sound of a human heartbeat. Taped to each desk, there is a message for each member of the audience, which reads:

> *'Tonight's performance will end with an invitation to leave this room and to be escorted next door for the final sequence of the work. As an honoured guest, once there, you may stay and look for as long, or as short, a while as you wish. The ushers have been instructed not to interrupt or disturb you; nothing will happen formally to announce the end of the evening – there will be no curtain call. When you are ready to leave, you will be escorted back out of the Hospital and to the street. We would only ask that you end this night quietly.'*

Enter a man in a white doctor's coat. He is carrying a clipboard and pens. Without acknowledging the audience he briskly turns on the lights and washes his hands at the sink as if he had just completed his rounds.

…Good Evening. With reference to the notes of which I trust you all have a copy on the desk in front of you…

He ensures that all the audience have read the notes, and reminds them that all mobile phoines and bleepers must be turned off, as we are in the middle of a working hospital. He puts on a clip mike. Speaking from notes, at a lectern, he begins his lecture.

The classic account of the original display of the seven canvases we now know as *The Seven Sacraments* of Nicolas

Poussin, 1594–1665, is that of Bellori, B, E, double L, O, R, I – Bellori. According to his *Lives of the Modern Painters*, Rome, 1672, guests fortunate to have obtained an invitation to the Paris residence of Poussin's leading French patron, *Monsieur* Paul Freart de Chantelou, C, H, A, N, T, E, L, O, U, would have been invited to view the paintings only under very particular circumstances. According to Bellori, only the most distinguished of visitors would be invited to leave the dining room and visit the private apartments in which the pride of Chantelou's collection was hung. His account suggests that only one guest, on any one particular evening, would be accorded this much sought-after honour.

A single servant would light the chosen guest through the darkened corridors of the house; he or she would then be seated and the room lit. Bellori significantly points out that this would all be accomplished in silence.

So, the room is dark (*As indeed it now is, the lights having been dimmed.*), but there would be light enough for you to see.

The seven canvases were hung in a single room, which was apparently kept otherwise unfurnished. Each painting was of exactly the same dimensions, one hundred and seventeen by one hundred and seventy-eight centimetres, and each was kept concealed behind a curtain. The Guest would indicate the canvas which he or she had chosen to view, the appropriate curtain would be drawn aside, and the servant would of course then quietly withdraw.

It was not possible to view more than one canvas at a time.

The great Italian baroque sculptor Gianlorenzo Bernini, in his autobiographical account of his 1655 visit to Paris, describes how he became quite unaware of how long

he had been left alone to examine the pintings. He also mentions kneeling in front of one of them.

Presumably so as to scrutinise it more exactly.

When the Guest had looked at the painting for as long as desired, he or she would indicate that the curtain should be drawn again.

It is of course now standard practice that should the servant or any member of the nursing staff assess that the patient requires additional privacy during an examination then the curtain should be drawn *without* a request being made.

Thank you.

The seven canvases, now usually referred to by their collective title, were originally individually titled with reference to the liturgy rather than to their ostensible biblical subject matter. For instance, Poussin's 1647 depiction of the apparition of the Holy Spirit on the occasion of the baptism of Christ in the River Jordan as documented in the Gospel according to St John, chapter one, verses twenty-nine to thirty-three, is properly designated *Baptism* – referring to the sacrament itself rather than to the documented Biblical occasion of its first celebration. The implication of this title is that the canvas may be read as simultaneously representing both the baptism of Christ and any subsequent historical baptism. For instance yours.

Or for instance mine.

However, Poussin's composition of attendant figures in this first canvas does not feature either of my grandmothers.

The other six canvases, in order, and with reference to (*Holding up a copy.*) The Book of Common Prayer of 1662, are: two, *Confirmation*; three, *The Solemnization of Matrimony*; *Penance*; *Ordination*; *Eucharist*, also known of course as Communion; and, finally, seven:

I should emphasise that this is not the order in which the canvases were painted, but the sequence in which they were intended to be viewed. When seen in this sequence the suite can be read as depicting seven precise moments, occurring in the appropriate chronological sequence, from a single day, with, for instance, *Baptism* taking place in the early morning, *Marriage* at High Noon, *Eucharist* later the same night, and then, finally...

It is appropriate to note here that statistically the most common time of death in terminally ill patients in this building is indeed the darkest and coldest hour of the night, which is most likely to occur at some point between three and six-thirty a.m.

Each of the seven scenes is illuminated by a different and realistically observed light source.

I should point out to those of you who were hoping otherwise that there are no angels or supernatural interventions enlivening any of the seven scenes.

The first of the canvases was completed in 1644; Poussin's depiction of *Extreme Unction*, which is in fact the last of the Sacraments in the liturgy; and the sequence was completed, after five years of uninterrupted work, in 1648. The subject matter of the series would of course have been familiar to the mid-seventeenth-century viewer. Poussin dressed his celebrants in the archaic costumes of the gospels and of first-century Rome; the

ceremonies themselves would have been familiar in their contemporary form to anyone who saw these paintings.

This is also true of us.

Whilst we are unlikely, most of us, to have been members of the congregation at, for instance, an ordination, or to have recently received the sacrament of penance on a weekly basis, few of us will not have attended, for instance, a baptism, or at least a wedding. Of some kind. At some time. For whatever reason.

We are perhaps one of the very last groups of people for whom this will be true.

In future we, just like everyone else, will have to bend down and read the labels under the paintings before we know what words the people in the painting are supposed to have just said, because we won't remember any of them from when we were children. Our friends will have to follow the service in the little book they give out at funerals very carefully, because they won't remember any of those words from when they were children. Our friends will have to be given a little Xeroxed sheet which tells you what words you should use when the parents hand over their child; or when you take hold of your partner's hand, in public; or when you finally get the telephone call which says *You should come now, this is it. Don't drive too fast. No, she's not in any pain.*

When we look at old paintings we expect to be shown a picture of the way they did things at that time and in that place. Not to be shown a picture of the way things might turn out this evening. In this building.

He picks up the copy of The Book of Common Prayer.

I keep on remembering them wrong. The words, I mean.

And of course people say that's good, it's good to forget; you have to let go, you shouldn't try and remember things exactly as they were, you have to say goodbye. But if these words are going to be forgotten, does it have to be me who is responsible for forgetting them?

(*Reading.*) **In this our time the minds of men are so diverse that some think it a matter of great conscience to depart from a piece of the least of their Sacraments, Rites and Ceremonies, they be so addicted to their old customs. And again, on the other side, some be so new-fangled that they would innovate all things, and so despise the old, that nothing can like them but what is new. But consider: it is not necessary that traditions and ceremonies be in all places one, and utterly alike, for at all times they have been diverse, and may be changed. It hath been the wisdom of the Church ever since first compiling of her Publick Liturgy to keep the mean between the two extremes, of too much stiffness in refusing, and of too much easiness in admitting any variations from it; therefore it is but reasonable that according to the various exigency of time and occasions such changes and alterations should be made therein, yet so as that the body –**

He undresses and puts on a surgical gown.

– the Body and Essentials of it have still continued the same unto this day; for although the keeping or omitting of a ceremony in itself considered is but a small thing; yet the contemptuous breaking of it is no small offence.

Without some ceremonies it is not possible to keep any order.

And moreover, these be neither dark nor dumb ceremonies, but are here so set forth, that every man may understand what they do mean, and to what use they do serve; for the Sacraments were not ordained to be gazed upon merely, but that we should duly use them.

When the curtains are drawn aside from the paintings, no-one will ask you what you are feeling. No member of the nursing staff will try and catch a glimpse of your face, or assume anything about what you are thinking. When the examination is complete, the curtain will be drawn again: and it will be time for you to rejoin the rest of the party at dinner. And the servant, at that point, will say: Will you follow me now?

Thank you.

The lights dim to blackout; a curtain is drawn back; the first slide, Baptism, *comes on.*

The first canvas depicts the **Ministration of Publick Baptism**; the familiar scene on the banks of the Jordan. In the centre, the first Baptism, that of Christ by St John. St John is the figure standing with his right hand extended. And assembled around him, the public. There are twenty figures in the composition; ten to the left of the Baptist and ten to the right, allowing Poussin a virtuoso display of classically-draped anatomies, particularly in these two figures immediately to the left of the Baptist, the two care assistants accompanying the next candidate being presented for Baptism. Who of course feel like complete fools. At their time of life... Being told that, as Godparents,

they must **faithfully fulfil their responsibilities both by the care of the child committed to their charge and by example of their own godly living**. And then being asked to answer the five questions – and in public too – the answers to the five questions, for those of you not familiar with the form of the Sacrament, being:

I renounce them all.

All this I steadfastly believe.

The third: **That is my desire;**

The fourth: **I will;**

And the last question of course is: **What is the name of this child?**

A hospital identification tag is affixed to his wrist.

The speaking of the name of the child is the precise moment when, as the prayer-book has it, this particular body is **engrafted, incorprorated, adopted, signed, received in the congregation**; is **welcomed**; and it is the moment when, in the exact centre of the composition, an exact thing happens: from the raised right hand of the Baptist, which divided the left hand side of the canvas from the right, and which is also aligned exactly with the waters of the Jordan; which divides the moment before from the moment to come; from the raised right hand of the Baptist, a single drop of water falls: and in the moment that it falls, the sun strikes the far side of the Jordan, and…a dove appears – which could, of course, depending upon your point of view, just as well be a trick of the morning light. The light on the far side of the Jordan is the same as the light over here; but better. More…golden. It is very calm over there – almost empty. You can see…almost

forever. No-one in the painting is actually looking over Jordan, they can't see what we can see – not the two care assistants, who feel like complete fools for bringing him so early for his appointment, he's been waiting there in that corridor for over two hours now – not the man kneeling here in a yellow robe with his back turned; but although no one is looking over Jordan, it is always there; always. Waiting. Promised. Always golden. Always...behind a curtain.

The last time that I looked at this painting I realised that I had forgotten that peace was supposed to be even a possibility.

And I had forgotten this group of four young men on the left hand of St John, who are naked, and wet, because they've just been baptised, and there is a cold wind this morning, but somehow, they aren't cold at all. One is drying his right arm; one bends his perfect back to dry his feet; one pulls on a blue sock; one turns and throws up his arms as he sees the sun come out over Jordan. And on their bodies there are no scars; they have not been hurt, they haven't steadfastly believed the wrong thing. What they desire has left no marks on them. Their skin is intact; people know their names and their dates of birth without having to check who they are. They're **welcome**.

And the man in the yellow robe, who is still dry, here on the left hand of the Baptist, wants all this, but he can't have it; not yet, not for another six paintings, because it isn't his turn yet. And that is why he is looking so intently, waiting so patiently, directing his gaze so firmly at the right hand of St John the Baptist. That is why he is so sure that peace is a possibility, as at this very moment...a single drop of water...

...falls.

The faint sound of a young child laughing. The second slide: Con-firmation.

The second sacrament. The ceremony of **Confirmation**, in the absence of a Biblical precedent, is given an archaeologically exact setting by Poussin; a Roman catacomb, used as a refuge by the primitive Church. The darkened basement of a building, in the middle of a city.

This second canvas also features twenty-one figures in its compositions, ten to the left and ten to the right. The central figure, barely visible, is in this case a corpse, laid out and awaiting burial in one of the three sarcophagi which form the architectural background to the scene. None of the celebrants is apparently perturbed by the presence of the corpse; no-one looks at it. Not even the children. Which is funny, because anything on the TV with bodies involved, I can't watch. I don't mean dying, it's anything with someone just lying there. Even people with their eyes closed, I go funny, I can't look. And in the crematorium, at the end, when they draw that little curtain, I find it such a relief.

In the wards, here, of course, they draw the curtains.

When it happens.

And in the mortuary here too they've got a curtain. In the room called the viewing room, where the relatives are shown the body after it has been laid out and covered. So that it looks whole again. They are ushered in, and the curtain is drawn aside, but behind it is a pane of glass, a hundred and seventeen by a hundred and seventy-eight centimetres. This prevents them from touching it and

trying to hold on to it, which they do try to do sometimes. When they break down.

This sheet of glass needs cleaning frequently, apparently, because people press their hands up against it.

When they have looked for as long as they need to, the curtain is drawn again.

I'm not sure whether the curtain makes it easier to forget what you have seen, or whether it makes you remember. Still, you should be able to say whatever you have to say with a body in the room, shouldn't you? And it's nice to imagine on these family occasions that the dead, in general, approve of the way we do things. And surely they like an occasion like this, a Confirmation, when there are lots of young people around...

So soon as children are come to a competent age, the age of discretion, **also Servants and Apprentices,** those of you that have them, **upon the day appointed, all that are then to be confirmed, being placed, and all of them in order kneeling before the Bishop, he shall say** – the order that you have to kneel in as you approach the Bishop to be confirmed, certainly the way we did it in our church, was in order of age – which is why the figure here in the right hand corner of the canvas is the youngest child, wearing a blue robe. He can't be more than what, two, two and a half, in other words he's far too young to understand a single word of what's being said, and he's certainly far too young to be expected to keep quiet during such a lengthy service; he wants his Mummy to pick him up, and he turns to her and she says *Sssshhhh!!!!, look how your brother's doing it, see?*

This child, the next in line, is seven. She hides under her

mother's robe and says, *It's not my turn yet.*

Is it?

This boy is fourteen. Which is how old I was. He kneels
in exactly the same place and in the same pose as the
man who was waiting to be baptised in the first canvas.
Now it is his turn to wear a yellow robe. Sometimes it is
those younger than us who get the chance; that is true,
sometimes.

He's doing it all very properly, this boy, he's learnt it all
off by heart, he's looking very intently, he directs his gaze
where he should, at the Bishop, but then at the very last
minute he spoils it by turning round and saying to his
Mother, *Am I doing it right?*

Behind him, the next candidate is fifteen, a girl, she is
very quiet, she's not kneeling, and her Mother has got her
hand on her right shoulder, and she's actually pushing her
daughter forward, saying go on, it's your turn in a minute.

The boy in front of her, five-foot-seven, tall for his age, he
leans forward; because it is his turn next.

And in front of him, the boy whose turn it is, now, the
oldest, the boy who has reached the age of –

I'm still fourteen.

I learnt it all off by heart…

What is your name?

Who gave you this name?

**Dost thou think thou art bound to believe and to do
as they have promised for thee?**

What meanest thou by this word sacrament?

– A sacrament is the outward and visible sign –

Rehearse the articles of thy belief.
What dost thou chiefly learn in the Articles of thy belief?
What is thy duty towards thy neighbour?

– My duty towards to my neighbour is to love him;
to hurt no body by word or deed; to be true and just
in all my dealing; to bear no malice or hatred in my
heart, to, to… – to keep my hands from picking and
stealing, and my tongue from lying, and to keep
my body – it was very hot the summer I was fourteen.
I couldn't keep my shirt on, I used to get burnt all the
time. I wanted someone to…take it off me, I was… I used
to get so…and it was always so very cool in the Church,
dark – and I learnt it all off by heart, and I promised, **to**
keep my body, not to give it away to anybody even if
they saw me with my shirt off, **to keep it in temperance**
and soberness; not to desire; I learnt **to do my duty in**
that state of life which it shall please God to call me
– but it was so hot, kneeling there, all of us in order; and
eventually it was my turn –

and the Bishop shall say,

My good child, know this, that thou art not able to
do these things of thyself

– and then you lean forward –

– and he shall lay his hand upon the head of every
one severally, saying –

At this exact moment, on the far left of the painting,

behind the Bishop, there is an unlit taper. One of the
altar-boys is reaching up to light this taper from one of the
burning candles on the altar – he steadies the candlestick
with his other hand; he doesn't want to get burnt. One
wick is burning…and the other is bare; and this is the exact
moment when the flame will leap from one wick to the
other –

Because I can walk now;
Because I am not too young to understand;
And I am not hiding in my Mother's robe,
And I won't be quiet, because
I learnt things by heart; it's the only way to learn them
when you're fourteen
And it is your turn at last,
And at last you lean forward, and he…

…places the thumb of his right hand exactly at the centre
of your brow and you hear everyone – you hear everyone,
severally, saying

O Lord,
Defend
This child.

The third slide: **Marriage.**

Dearly Beloved, the third painting depicts the sacrament
of Marriage, and shows us **gathered together here**
in the sight of the congregation and in the face of
considerable public opposition **to join this man and this**
woman in holy Matrimony, which is an holy estate
and is commended to be honourable among all men,
and therefore is not by any to be enterprised, nor
taken in hand, unadvisedly or lightly; to which the
celebrant shall reply:

How very true.

There are twenty-four figures in this painting. The priest, in the centre, is in a yellow robe. There are ten guests with the groom, including a woman on the far right of the picture standing behind a pillar whose face you can't actually see, and ten with the bride, including that man standing right over there by the door, who I see has chosen to wear black, which I think is a very funny thing to wear to a wedding; he looks very unconvinced by the whole proceedings. And the twenty-fourth guest…is me. I'm here to provide the ring. Because I'm not fourteen any longer; and I choose to wear a ring. (*He takes off and holds up his wedding ring.*) And Poussin has placed it here so that the light from a window here on the left hand side of the painting falls exactly on it. Everyone is exactly placed. So that everyone can see. That's the point, after all; you can't do this sort of thing in private.

I was sixteen the first time I saw two people actually doing it.

They made me an usher; I had to say to everyone, *Bride, or Groom?* – meaning, are you with the Bride, in which case you have to sit on the left hand side of the aisle, or are you with the Groom, in which case you have to join the figures on the right hand side of the composition. They ought to ask you that on the door of the club, really. You know; *Have you been here before, and are you Bride or Groom?* It's a very good question: bride or groom, left or right, we haven't got all night dear, we close at two…

When I went to get the ring, the woman in the shop was very brusque. Rather forward, actually. The thing is, according to the brochure, many people now find the

traditional plain gold band frankly outmoded, and so I
thought, well, let's not be outmoded, let us not: tradition?
– ha!… Well, it was bewildering. The choice, I mean. And
there you are again you see, first of all you have to choose
between *his* and *hers*. Which as several of you here tonight
will I am quite sure be able to testify, can be such a tricky
choice to make, especially before the wedding night – but
choose you must, because apparently *hers* start at £750, *his*
at £2100, because *his* are chunkier. Men generally prefer
it chunkier, I was told. It was all I could do to silently
nod my head in agreement. We moved on to the next
tray. 'Modern Simplicity'…well Modern, yes; Simple, I
don't think so. Something a little more showy?, she said;
So my friends are always telling me, I said. White gold
interlocking with matching gypsy-set pink tourmaline
was suggested. Well somebody had to speak up. Seems
a little *ostentatious*, I said. Seems like someone feels the
need to raise their voice, I said. Newfangled, I said; what
on earth would I be trying to prove? Which is also a very
good question… Engraved?, she said. Engraved?, I said
– Engraved, Tattooed, Scarred for Life! – Bruised… On
the surface or on the inside?, she said. Quite, I said. Time,
date, names? Very important, I said; so easily forgotten. A
few choice words?, she said. How long have you got, I said.
Something basic, like 'Everlasting Love', was suggested.
Something basic like full civil rights in the lifetime of this
parliament was what I had in mind, not that I'm feeling
particularly civil, I said, and she said, *Are you taking the piss?*

No.

Though that is also quite a good question.

'Make of our hearts one heart'?, she suggested; which
seemed to me to be pushing things a little too far once

again – and it did raise the whole issue of his and hers
again I felt, I mean it's a lovely sentiment, lovely, in fact I
think in a way those are some of the most effective lyrics
Stephen ever wrote, but look what happened to Maria and
Tony – 'Even death can't part us now…': yeah, right, *in
your dreams*, I mean you do find yourself thinking, don't
you, are they the only two people in the entire cinema
who've never read *Romeo and Juliet*, don't they know what
happens? There is a place, somewhere, absolutely, but
really, George Chakiris maybe, Natalie Wood I don't think
so – she said could I just remind you **that no person
whatsoever shall in any interludes, plays or by other
form of open Words declare or speak any thing in
Derogation, Depraving or Despising of the Form or
Manner of the Sacraments**, *The Book of Common Prayer*,
1642, and I quote – I said *please*; please don't tell me that
you think I'm joking. Not with the life I've led. Not with
the life I'm planning on leading. The life we're owed.

Hmmn…traditionalist, are we?, she said. Assimilationist.
'Virtually Normal', Southwark Cathedral, all that sort of
thing. Something in Latin then, perhaps, she said.

Well, **to speak darkly is a kind of silence**, John Donne,
1627, I said – and I quote. No, I said. So how about this
one…it was my Mother's. It fits me; and inside, it says:

If any one here knows cause or just impediment why these
two persons should not be joined together, let him now
speak or else hereafter for ever hold his peace.

And then:

**The minister shall cause the Man with his right hand
to take the woman by the right hand and say after
him: I take thee… And then the priest, taking the**

**ring, shall deliver it unto the man, to put it upon the
fourth finger of the woman's left hand, and the Man
holding the ring shall say: With this ring I thee wed...**
and all the guests lean forward, because this is the good bit,
the bit they came to see; and the woman behind the pillar,
whose face we can't see, that is in fact my grandmother,
and I'm so glad she's here to see this. And the man in black
watches, very intently; he stares – but not at the ring, but
at another man whose face says I know; I know. But people
do say them, they say them all the time, these words – and
they let other people hear them say it...and wouldn't you?
Can't you imagine what it's like to want to say those words
– even in secret, when it's late, and you're tired, and you
can't even see his face, and it's filthy what you're doing,
really filthy. Or amongst the faithful, when of course
no one in here minds if you kiss him – but you two mind
how you go on the way home tonight... Or right in the
middle of town, in the middle of the afternoon, right in
the midst of the congregation, when **the priest shall then
say** –

Notice how in this composition the sun is about to shine
down through an archway which is seen through the
window which is directly above their hands as they are
joined, and the window is garlanded with flowers...; take
a step closer...can everybody see?... See, as the sunlight
comes through the arch, and through the window and
through the flowers and now exactly strikes the third
finger of her left hand –

Oh God I hate weddings. Somebody always comes up to
us and says *Hello, is this your friend?* Well, I haven't seen you
since – well since you were kneeling down there in that
yellow robe in the second painting! 'To have and to hold...'
ah – it's such a lovely service, isn't it? – 'With my body I

thee worship,' aren't they just the lucky couple – and look at you now, all these years later, still going to other people's weddings… I see you've chosen to wear black – funny thing to wear to a wedding, I see you've placed yourself as close to the door as you can, but you haven't left, have you –

And he hasn't.

And we can have no idea of what he is thinking, that man over there by the door. We should make no assumptions at all about what he is feeling as he listens very carefully, not unadvisedly, or lightly, as the priest says

Those whom God has joined together
Let no man –
Nobody –
Let no man put asunder.

Don't even *touch* them.

As he slides the ring onto his finger, a flash photograph is taken.

I will give thanks
With my whole heart;
Secretly, among the faithful; and in the
congregation.
Psalm 111

The fourth slide: Penance.

…lovely the sun coming out like that. Needn't have used my flash I suupose really. Lovely. And lovely flowers I thought. I do like a good photo. And a video's not the same thing at all in my opinion, because with a video you can't put it in the book, can you? With all your other photos. Turn the pages over and see the people from one photo

in another. There you are in your christening robe, there
you are at Audrey's wedding and now look at you. And
of course we all missed Grandma but there she is on the
beach. Nice to have something to look back on. Nice to
have people with you.

On the wards here, you'll often see that people have a
photograph or two on the little bedside cabinet – well
they can be very impersonal these wards, can't they? And
when somebody dies they say it's a good idea for the first
few months to have a picture of them up in every single
room so that you can talk to them whenever you need to
ask them a question or something. Also that way they can
be watching you the whole time, you don't have to worry
about ever being out of their sight. It's nice to have one of
them by the side of the bed.

Every night when I go to bed and as soon as I get up in the
morning.

Funny though, but anything on the TV with someone
dying, I can't watch. Can't watch it at all. Can't look at it.

– I'm sorry. I always cry at weddings. Actually I don't know
about you but I cry a lot these days. I was watching this
film this afternoon it was ridiculous I –

Oh

I'm sorry.
I try and only do it when I'm on my own. Never in public,
I –
Oh I'm sorry. I try never to actually let myself go you see
because once I've started I'm afraid I'd never stop you see,
I don't know –
Oh I'm sorry. Excuse me.

Catch me walking down the street crying! I decided to give all that up almost nine years ago now. It was getting embarrassing. I used to be just walking down the street and then I'd –
Oh!

Sorry. You see what I mean? Embarrassing. Now I try and do it just when I'm indoors. Not in front of other people. Obviously I have to practise not making too much noise when I do it, even then – I find having the television on helps, and also a towel. Sort of on my face. I mean you don't want people to pass the house and think oh dear what on earth is that woman crying for do you? I mean someone might come and knock on the door and ask you if you were – yes, fine, really, no thank you...I'm sorry. Oh dear, could you? I'm sorry, it's not as if I haven't practised believe you me. I don't want to upset anybody you see. I mean I wouldn't ever make a point of it. I wouldn't ever, I mean I just wouldn't, I wouldn't ever walk into a room, I wouldn't ever go into a dark room, full of men, because... Because all the men there would stop and turn and watch me doing it. That's my absolute nightmare, I –

Oh.

Oh I want it to stop. This...sadness.

(*Beginning to sound drunk.*) – God I get myself into such a state!!

The fourth of the paintings, portraying the sacrament of Penance, depicts the passage in the Gospel of St Luke in which an unnamed woman – What did you just say? What did you call me? – traditionally identified as Mary Magdalen, who is shown in this picture with her right shoulder exposed – oh I'm sorry – but I hadn't let myself

go all evening, and I – and they were all bloody watching me – I went right up to him, and I took hold of his foot in my right hand and I – I couldn't think about anything else – I – I was…

…**a woman who was a sinner, when she knew Jesus sat at meat at the Pharisee's house, she stood at his feet behind him, weeping, and began to wash his feet with her tears, and did wipe them with the hairs of her head, and kissed his feet, and anointed them. And when the Pharisee which had bidden him saw it, he spake within himself, saying, This man, if he were a prophet, would have known who, and what manner of woman, this is, that toucheth him; for she is a sinner. And Jesus answering him said unto him, Thou gavest me no water, but she hath washed my feet with tears; my head with oil thou didst not anoint; but this woman hath anointed my feet. Thou gavest me no kiss, but this woman since the time I came in hath not ceased to kiss me feet; let her alone. She hath done what she could. This she hath done shall be spoken of; wherever this gospel shall be preached, this that she hath done shall be spoken of for a memorial of her. And he said to the woman: Go; go in peace…**

…I'm sorry? Peace? What's that then? Is that what you call what I've never 'ad?

He opens a can of beer.

She had no bloody shame – she did it right there in front of all those men. She bent over – *and I've done that* – she took 'is foot in 'er 'and – *and I've done that* – she opened 'er mouth, and she …

Pardon me. No, really.

Go on; pardon me. Pardon me for exposing the back of my
neck to a stranger's gaze. Pardon me for saying you've got
no idea how much I need this. Forgive me. Shut me up.
Push me down with one hand on each shoulder, go on,
make me. Forgive me, for I have sinned right down there in
the very back of my throat, with three fingers down there,
with the heel of a boot, with how bloody *thick* it is, with
the whispers, the noise, the sounds I let out, I can't believe
the words I say sometimes, *Jesus!*

Make me forget my own name
Make me not care, *come on, make me!*
Make me do it again, and slower.
Turn the light on.
Make me do it for money.
Make me do it in public places.
Make me do it in my parent's house.
Make me do it with your son.
Tell people all about me – and then forgive me.
Flood me; dissolve me; wash me away;
Scatter me in drops, spill me, pour me out;
Make me despair.
Wear me out, wring me out, beggar me;
Wither me,
Spend me,
Waste, enervate, destroy and demolish me;
Make me despair – and then forgive me.
For I acknowledge my faults; make me a clean heart, *break
me*...
And then forgive me.
Excuse me.
Pardon me.

Pardon?

Pardon me?

Catch me being one of those people who do it in public.
Cry, I mean.
I can't stand that sort of thing.

The Magdalen is not depicted alone with Christ. Six of the
other guests at the feast are staring at her and four of them
are pointing at her, they include a man having a drink who
has no idea what she is talking about and who obviously
doesn't need forgiving for anything, that's probably
because he's got nothing to confess; two men saying to
each other, did you see that? – did you *see* that? – and a
man looking out of the picture straight at the viewer (the
only one in all of the seven canvases who does that) and
raises his left eyebrow; and his left eyebrow says: I expect
you all saw that.

And at the very front of the picture, a young man, who has
heard and seen nothing, kneels, and very carefully, pours
out a pitcher of red wine, as she pours out her heart...
without... spilling...a...drop.

Red wine is poured from the beer can.

In the third painting, the Bride has her hair covered, and
in this fourth painting the Magdalen lets her hair down;
the Magdalen's skin is exposed, and the Bride's is covered.
One has a name, and the other doesn't. Everyone is
looking at them, that's the same in both pictures, but don't
tell me you haven't noticed the difference; I noticed it even
when I was sixteen. The difference is in the third finger of
the right hand. Even if the ring has been taken off an X-ray
will still reveal the characteristic callous just below the first
joint of the third finger thus enabling us to distinguish

between the accepted, and the unacceptable.

There are no women at all in the next picture.

Thank you.

The fifth slide: **Ordination.**

According to Bellori, **Ordination** was painted in Rome, in seventy-seven days, in the summer of 1647. No guests were admitted or interruptions allowed by Poussin during this period. The Biblical archetype of **The form and manner of the ordering of Priests**, as the Anglican *Book of Common Prayer* styles it, is that recounted in the Gospel according to St Matthew, chapter sixteen, beginning at the sixth verse:

And Jesus answered and said unto him, thou art Peter, and upon this rock I will build my church, and the gates of hell shall not prevail upon it. I will give unto thee the keys of my kingdom, and whatsoever thou shalt bind on earth shall be bound in heaven, and whatsoever thou shalt loose on earth shall be loosed in heaven. (*Indicating the picture.*) Heaven; Earth; Matthew, Bartholomew, Phillip, James, wearing a yellow robe, Simon, Judas Iscariot, Thomas, Andrew, Thaddeus, James and his brother John, Peter – all of whom are **apt and meet to exercise their ministry duly, and whom the Bishop shall commend to the prayers of the congregation, as followeth; that they be delivered from all blindness of heart, from pride, vainglory and hypocrisy; that they be delivered from envy, hatred and malice, and all uncharitableness, from hardness of heart and from contempt; and that they will, as our ministers, strengthen such as do stand and raise them up that fall.** And then the Bishop shall

say, **Take thou Authority** –

But none of them does. Because the fifth canvas does not show us the keys being taken; it shows us the moment when he says, *Go on, take them.*

And no one there does, which is odd; because someone has to.

Someone has to pick up the knife and perform the operation, it's not something you can do for yourself.

Someone has to make a diagnosis.

Someone signs the paper; someone has to.

Someone prepares the budget; after all, someone somewhere has to decide what things are worth these days.

Someone has to be prepared to explain, when the kids ask.

Someone has to pronounce the verdict; has to actually say the words.

Someone has to sign the paper and someone has to watch the door actually close. Someone has to.

Someone must be the judge, if there is to be any judgement.

Someone has to say that if there is Justice there must also be Law.

Someone has to take the key. Because someone has to turn it in the lock and shut people like that away for ever and when they do you can't just ask to be excused, you can't just say that you don't want to watch.

Somebody has to be the keyholder. Why should it be somebody else?

Are you scared?

Wouldn't you say that, at our time of life, that's frankly ridiculous?

His arm is raised in the painting's gesture of holding up the keys. He takes his own pulse. An injection.

Which arm would you like me to use? Just clench your fist for me a few times.

Sharp scratch now…press down hard for me.

He presses a plaster over the mark the needle has left. He takes pills.

He takes off the surgical gown and lies down naked.

Lights Out Now Shall We?

In darkness:

You will have noticed, those of you that were brought up with these words as I was, that I keep on remembering them wrong. I have erred, and said things like…

I've lost my place. I have left out the words which I ought to have said, and I've put in those that I ought not to have put in, and I just can't help it.

Thank you.

The sixth slide: **Eucharist.**

In the sixth painting there are the same thirteen men. But they are in a room now. The upper room. And it's later. And darker. It is the night he was betrayed.

In thy preparation to this holy and blessed Sacrament, make this present day that day, this night, that same night; and consider what he did, and

remember what you have done. He spent the time till night in prayer. I dare scarce ask thee whither thou wentest or how thou disposed of thyself, when it grew dark, and after, last night... About midnight, he was taken and bound with a kiss; art thou not too comfortable with him in that? Is that not too literally, too exactly thy case, at midnight to have been taken and bound with a kiss...and from hence, first to Annas, then Caiaphas...there he was examined and buffeted and delivered over to those from whom he received derisions, and violences, the covering of his face, the spitting upon his face, the blasphemies of words and the smartness of blows, and then to the satisfaction of your fury, your haste for execution, to the scourging and the crowning of thorn until there, there hangs that body, embalmed in his own blood alive. There are those bowels of compassion, so manifested that you may see them through his wounds.

All of which is still to come.

At this exact moment, his body is not torn up like bread to be passed around, it is not broken; it hasn't been examined, it's not bleeding, there's no blood anywhere, and of all the one hundred and twenty-one figures depicted in the seven canvases this is the one body that will never come into this building. This is the body that hangs there for ever, behind a curtain. And this is the body to the exact centre of which, with his right hand, not his left, he points, saying, **This is my body, which is given for you**. And at the exact moment that he says this, the Apostle to his right turns his head sharply, because he has seen that Judas is about to leave the room. Judas stands where the guest in black

stood at the wedding, right by the door, but he doesn't stay and watch. He stands where the Magdalen stood, but he doesn't ask to be forgiven. He is the only figure in all of the seven canvases who is shown actually moving; we see him walking out of the picture. Because of this, we cannot see his face. And because of that, we can have no idea at all of what he is thinking.

Thank you.

The seventh slide: **Extreme Unction**.

We are all afraid to speak of death.

We are never thoroughly awake, but pass on with such dreams and imaginations as these; I may as well live, as another; and, why should I die, rather than another? But awake, and tell me, who is this other that thou talkest of?

Is it someone somewhere in this building?

When Goliath armed and fortified this body; when Jezebel painted and perfumed this body, they said in their hearts, can these bodies die?

And they are dead...

Look upon the water, and we are as that, and as that spilt upon the ground: Look to the earth, and we are not like that, but we are earth itself. At our tables we feed upon the dead, and in the temple we tread upon the dead, for when we meet in a Church, God hath made many echoes, many testimonies of our death, in the floor, and in the walls, and in the windows, and he only knows whether he will not make another testimony of our mortality, perhaps of the youngest

**among us here tonight before we part, and make the
very place of burial, our deathbed. For indeed, no
one knows their end, or the number of their days.**

In the last painting, the seventh, there are again twelve
figures gathered around a thirteenth. They are all there.
The quiet girl from the *Confirmation* is there, and she's still
fifteen. The boy with the candle is there, he's kneeling
with it now, because there's hardly space for everyone
around the bed. The grandmother is there, and she's
crying. The best friend, the man who threw up his arms
when he saw the sun coming out over Jordan all those
years ago is there, but he's not a year older, he throws his
arms up again, he so longs to take the figure on the bed
in his arms, but he knows you can't ever be sure if they
are in pain or not, can you? Someone's brought the baby
– the nurses must have said it would be alright to do that.
Someone asks the Doctor questions, as if that could help;
and the Doctor says the right things – because someone
has to. One woman covers her face, she really doesn't
want to upset anybody – and you can never be really sure
if they can hear you or not can you? Another woman sits
at the foot of the bed and weeps. She has no shame, and
her shoulder is bare. The Nurse is clearly exhausted. It's
been a long shift. It could be any time between three a.m.
and six-thirty, she really has no idea. She is looking at the
window and wondering if that is really the dawn she can
see.

The twelfth figure, right on the edge of the bed, the man
in the yellow robe, is me. He is reaching out with his right
hand, gently, and he is going to touch the back of the hand
of the person on the bed. The first time that you see this
painting you may think that there is so little air between

his fingers and the dying hand that they are touching already. But in fact he is waiting for an exact moment; the moment when the nurse says

Yes I think this is it now

The moment when you lean forward and say

Go now.
It's alright, go.
Go.

The moment when the breathing actually, finally stops; when the last breath isn't followed by a next one.

And at that moment, I promise you, no one will ask you what you are feeling.

Of course, it may not actually happen like that. It may be sudden; not everyone may be able to get there on time. But that is the great virtue of this, the seventh painting, the last one, that whether you need to use it to remember, or whether you need it to help you imagine

what you just can't imagine

you do

know that this has happened, or will happen, to everyone who has ever seen this picture. You do know that whenever you need it, it will always be there; behind a curtain.

Will you please all follow me now.

He leaves the room. In a second room, which is quite silent, there is a hospital bed, with the screens drawn back. He sits quietly beside the bed, head bowed, holding the hand of the person lying in it – except that there is no person there. Only a hollow in the pillow indicates their presence.

People stay in this room for as long as they need or want to. As they

leave the room, and make their way back through the hospital corridors, some may be aware of a faint sound of birdsong.

The Verger Queen
or Bette's Full Service
2000

Bette's Full Service is very much a *pièce d'occasion*. It was written to order for one of my closest colleagues, Bette Bourne, at the request of London's queer performance producers *extraordinaire*, Amy Lamee and Simon Green, aka Duckie. In 2000, Duckie had decided to expand its riotous annual celebration of St Valentine's Day beyond the usual format of a gay disco in the legendary Royal Vauxhall Tavern, and they invited several distinguished (and a few merely notorious) lesbian and gay performers to create site-specific performances in various atmospheric corners of Vauxhall, which the audience were to encounter as part of a guided walking tour of the historic neighbourhood before ending up back at the pub to dance the night away. Bette and I were offered nearby St Peter's Church as our venue. We visited it, and were both immedi-ately knocked out by the glorious nineteenth century polychrome interior hidden behind its sombre and exhaust-fume-stained exterior. We were also both fascinated by its historical connections to the more dubious end of the south-of-the-river entertainment industries, both in the eighteenth-century heyday of the Vauxhall Gardens (the high altar of St Peter's, extraordinarily enough, is said to mark the site of the Garden's infamously lascivious Neptune Fountain), and again at the turn of the nineteenth century, when the surrounding Vauxhall streets provided housing and lodgings for an extraordinary concentration of artistes from the London music halls. After an hour spent in the church, we repaired to the café next door, and over a cup of tea, sketched out the piece. Once we had conceived the character – who we called *The Verger Queen* – the piece practically wrote itself.

The Verger Queen is an ex-Vaudevillian of some distinction (or possibly pretension) who has ended up working (or possibly just dossing) in a church. Clearly delighted to have a captive congregation, she gave the impression that while her accent was pure Hackney, she had lived around Vauxhall for years – in fact

for more years than the laws of human biology would ordinarily allow. In the course of her monologue, she continually switched back and forth between several strands of different text. Sometimes she seemed to be a church verger announcing the service; sometimes a guide quoting the guide book to St Peter's; sometimes she rambled through very personal memories of the church and its parish; sometimes she wandered off into fragments of old music hall routines, which she clearly delighted in performing in the inappropriate surroundings of a church. Her ramblings often gave the impression that she was, to put it politely, at least one hymn short of the full Evensong.

The sight of Bette frying up a sausage while pottering through the remains of a gentle tap routine, watched over by the shadowy saints and frowning angels who hover above the high altar of St Peter's, was one of the most touching and extraordinary of our fifteen years of collaboration.

The piece has a deliberately, unashamedly emotional ending. Bette topped the bill for the evening, and once her service was over, the congregation had only a three-minute walk before they were in the Vauxhall Tavern, getting down to the serious business of celebrating St Valentine's Day in traditional queer fashion.

The Verger Queen
or Bette's Full Service

A St Valentine's Day Mass(acre)

Once the congregation have taken their places in the pews, the shadowy, deserted-looking church is disturbed by the sound of a terrible coughing noise, apparently emanating from the pulpit. An arthritic hand appears, followed by the rest of THE VERGER QUEEN. Her appearance is vaguely ecclesiastical – a dusty, mildewed soutane topped by the white-face comedy make-up and hair of an Edwardian music hall monologist. She wears Little Tich-style tap boots with elongated toes. Apparently unaware of the congregation, she is putting up the numbers of the hymns for the next service. The first number is 69. She offers up a small but heartfelt sigh of recollection, and then, continuing to put up numbers, starts muttering to herself…

All the ones…Legs Eleven.

Two fat ladies…Twenty-two…

She catches sight of the audience.

Oh!

Dearly beloved…we are gathered here together in the sight of…and on the site of…erm…on the site of the old…the old – you know…*history…*

She is clearly very confused…but tries to get her thoughts in order.

Are we sitting comfortably…

Thank you all very much for coming this evensong…
Now: just before we sing HIM magazine issue number 69, a few Parish notices…:

We pray for the Queen, and for the Queen's Mother, that she may get over herself and tell our Peter that she hopes he'll be very happy in his chosen way of life with that rather striking boy who works backstage at the Empire… We pray for Mrs Whitmore from down the street who has lost her dog again, if anyone's seen anything rough-haired and appealing wandering the streets asking to be taken home by strangers please see me after…

Monday's confirmation class will be…confirmed later; Matins will be on Tuesday; Wednesday there will be no Matinee, but later tonight there will be a special massacre for St Valentine – there will be a 'specially messy massage parlour just down the road in Kennington –

There will be a St Valentine's heaving Mass of intertwined male limbs round the back of the vestry – white vests, all of them, they'll be wearing, white, white cotton, washed white in the blood of the Lamb, pure as the driven snow and twice as tight in all the right places…

Where was I?

She looks round, as if coming to her senses; a moment of lucidity.

Nice gear they've got in here haven't they?

Gets down from the pulpit and looks around. Having investigated the inlaid marble pavement in front of the sanctuary railings, she delicately tap-dances to a fragment of 'All Things Bright and Beautiful'.

A rare survival of the early Victorian High Church Liturgical Movement Tap Floor there (*Indicating the carving on the pulpit.*) …St Peter having a bit of a chat with a Roman Centurion…very nice… (*Indicating the ceiling.*) … nice bit of vaulting up there…over there you have your Central Vaulting Shaft, carved with your four Cardinal Virtues: Latitude, Longitude, Fortitude and Attitude…

(Quoting from memory from a very pompous guidebook.)
'On entering the lattie through the West Door the
overwhelming impression is of the height and harmonious
proportions of the interior. Archbishop Edward Benson
is said to have told the architect, on commissioning his
design, "Mr Pearson," he said, "Mr Pearson, the question
to ask oneself is not is this admirable, or is this beautiful,
but does this send one to one's knees." '

In this, as in so many things, the Archbishop of blessed
memory certainly had a point.

She potters; she dusts something sacred in a familiar manner.

Years, I've been kneeling; years. Genuflection's been a way
of life to me...

Up there of course in the dress circle you've got your
choir. Many many choirboys we've had here in our
time. Twenty-two of them. Hand picked. Oh yes. Very
strict on the issue of handpicking was our Uncle Ernie,
Choirmaster to the Parish of St Peter. 'All Things Bright
and Beautiful' – I should coco. Purity, Tone and a fine
unsullied young Vocal Organ nestling beneath freshly
laundered folds of chaste linen, that was what our Uncle
Ernie looked for in a choirboy, and if that meant individual
coaching, individual coaching was what you got. *(Tenderly.)*
Wednesdays, I got mine...

...individual coaching, in front of the gas fire – and an
Eccles cake after, if you hit that top note to Uncle Ernie's
satisfaction. Open that throat, lad, he used to say to me,
open that throat...

Bless Him.

May he rest in peace.

A tender pause; remembering…then back to the guided tour and the dusting.

Lovely set of Stations of The Cross we've got there hanging in the hall… The Scourging, that is. There he is, being scourged, bless 'im, scourged by the Imperial Roman Guard, or the Household Cavalry as we used to call them in my day – *Punishment!!* – young people today don't know the meaning of the word!!! Fifteen lashes from a fully uniformed Corporal in a luxury furnished flat just off the Streatham High Road that's what they need. Made me the man I am today I can tell you.

And over there of course we've got the Three Marys. Offering Consolation. The Big Mary in the middle there is on the game of course, as specified in the Gospel, St Mark, chapter eleven, verse fourteen – not that you'd ever know she was in four inch heels under all that drapery. Fifteen years bringing a little light relief and glamour into the lives of solitary gentlemen – at very reasonable fees I might add – and look at her now, immortalised in late nineteenth century alabaster on the north aisle. Funny thing, history.

Bless her.

And next to her, you want to take a little look at that plaque there on the way out, 'Donated by Sister Vera', it was – Sister Vera, or Stanley as we knew her. A pillar of strength she was to me in the war, our Vera. There we'd be, stumbling over ourselves in the blackout, trying to get our hassocks disentangled from our cassocks, and Oh Vera I'd say, I can't tell me Apse from me Elbow – pitch black it was, pitch – am I facing the West End or the East End? – and then Sister Vera used to say to me, she'd say, East End, West End, I don't care if it's from Stepney or Soho bleedin' Square, when it comes, you've got to face it, girl, face it!!!

An inspiration to us all in those dark days of no nylons she was, our Sister Vera. An inspiration.

Bless her. May she rest in peace.

Pause.

Down there at the back of the stalls you've got your actual font. (*Big build up…*) George Robey, Dan Leno, Little Tich. Will Hay, Max Miller, Stan Laurel… (*Punch line.*) None of them was baptised here. All lived round here one time or another though. They were going to put up blue plaques for all the places Charlie Chaplin lived in Vauxhall when he was a kid, but they had to give up, 'cause every time they couldn't pay the rent his mother'd flit with the kids and so Charlie'd lived twenty-seven different places by the time he was eight.

Funny thing, history. As the comedian said to the landlord.

Bless him.

And up there of course we've got the High Altar… – very High – commissioned by the Reverend George W Herbert, provider of soup kitchens and 'specially embroidered vestments to the poor of Lambeth, who in 1873 contravened the regulations of the Judicial Committee of the Privy Council by insisting that his altar boys *all* wore scarlet cassocks; the Reverend George Herbert, ladies and gentlemen; Tractarian, Ritualist, and, I should say from a quick varda round his taste in interior decoration, bless her. Definitely… – the High Altar, boys and girls, built on the site of your actual Neptune Fountain from your Vauxhall Pleasure Gardens of sainted memory, demolished in 1859, gone but by no means forgotten, haunt of two-hundred-years'-worth of ladies of fashion, ladies of the night, nightingales and Italian waiters specialising in swift

and elegant service, bless 'em. George Frederick Handel,
Doctor Johnson, they all played here you know. Oh yes.
Crowds? I should ro-co-co... Wednesday seventeenth of
June 1732 – very popular Wednesday nights were, those
shrubberies were packed, packed I tell you – still as the
Verger said to the Archbishop, show me a bush, and I'll
show you two homosexuals behind it, eighteenth century
or not – anyway, that particular Wednesday, we had a slight
spot of bother. The Prince of Wales was just settling down
to cold collation in the Gothick Pavilion when one of the
Italian waiters aforementioned got carried away by the
sight of himself reflected in a chandelier, and before there
was so much as time for a Baroque Musical Interlude she'd
reappeared dressed in a rather fetching off-the-shoulder
Spitalfields silk sack-back farthingale with matching
accessories and was ordering saveloys at the top of her
voice...

Defrocked pretty sharpish, she was.
Bless 'er.

Funny thing, history.

She produces a pack of sausages from some inner recess of her soutane.

You can build an altar on a fountain;
You can turn a shrubbery into a bus-stop;
You can throw her out of the Pleasure Gardens and you
can take a queen out of her frock;

But you can never, never take the frock out of the queen.

Not when she fancies a saveloy.

*She begins to fry up her sausage in a blackened frying pan on a Primus
stove she has set up on a side altar.*

D'you know, you couldn't get your hands on a decent sausage all the way through the war…not even for ready money.

While she fries her sausage, a little song: patter first, then chorus; all in a doddery half-whisper.

East is East and West is West –
We can no more walk the Mayfair way than they can walk the Lambeth way –
You don't understand…;
Lambeth you have never seen –
The sky it ain't blue and the grass ain't green;
We haven't got the Mayfair touch – but that don't matter very much;
We play a different way –
Not like you, but a bit more gay –
And when we have a bit of fun – Oh Boy!…

Ant time you're Lambeth way
Any evening, any day –
You'll find us all, doing the Lambeth Walk – Oi!
Ev'ry little Lambeth gal, takes along her Lambeth pal –
You'll find us all, doing the Lambeth Walk – Oi!
Ev'rything's bright and breezy, do as you damn well pleasey –
Why don't you make your way there –
Stay there –
Play there –
Once you get down Lambeth way, any evening, any day
You'll find yourself, doing the Lambeth Walk – Oi!!!

When her sausage is done, she spears it with a fork; with much in-nuendo.

For what we are about to receive, may the Lord make us

truly grateful (*Suddenly deeply moved; pause.*) I'm sorry – it's just I was suddenly reminded of our Uncle Ernie.

It comes over me like that sometimes. Funny thing, history.

No, no, don't mind me. You young people all go out and enjoy yourselves, you leave me here with just a saveloy and a semi-derelict ecclesiastical monument in need of a severe dusting for company, why don't you; go on, I've 'ad my moments, don't you worry about me.

People say to me when I'm showing them round this place, they say, I don't know how you remember it all. And I say,

Her voice changes from that of the character to something very close to Bette's own voice.

I say:

Darling,
Some things, a queen never forgets.
Never.

I remember the last time like it was...oh, yesterday...
I was waiting for the night bus.
And cold – cold it was, very. Just that time when the last of the boys who have stayed up late have gone home, together, and the first of the people who have to get up early, haven't.
Very cold.
Standing there waiting for a bloody night bus, at my time of life...
And then this old Ford van pulls up.
And oh no, I think. Not again.
Not tonight. I've been dealing with this shit since 1732...
And the window winds down...and...

And there's this blond.
With arms...that could hold you tight... Forever;
And he says
D'you want a lift?
And I said:
Don't mind if I do... Bless You.

Funny thing, history.

To the tune of 'My Old Man Said Follow The Van', with great
warmth, to send the congregation off to the pub:

This young man, said 'Get in the van –
I'll drop you off' – well, what was I to say?
Off went the van, with us stuffed in it;
He said he knew the way, that it wouldn't take a minute
–
But he dillied, and dallied;
He dallied and he dillied;
I dropped the map – his hands began to roam...;
So...:
We stopped off at the Vauxhall for a large gin and tonic
And we can't find our way home –
I'm not complaining –
Can't find our way home! –
Know what I'm saying?
We can't find our way home!!

Thank you, thank you (*He blesses the audience.*)

And now:
In the name of how's your father,
How's your son,
How's your cousin with the van and how's your Uncle
Ernie;
In the name of Sister Vera, and of all the Vauxhall ghosts:

Have a fabulous St Valentine's night;

Go in peace, and break the law.

Ah, men.

Does You Good
2001

This piece, like *The Verger Queen*, was written for Bette Bourne to perform as part of one of Duckie's post-modern nocturnal gay history walkabouts. It was the final performance piece in an evening that started in the Trumans Brewery off Brick Lane, and then led its audience around some of the darker corners of Spitalfields before ending up in Toynbee Hall, at the Aldgate end of Commercial Street.

The old lecture theatre in Toynbee Hall is a wonderfully gloomy, atmospheric hall dating from the late 1920s, with rows of red plush seats and a raised stage more redolent of lectures and speeches than anything too theatrical. It inspired Bette and me to make something very quiet, very meditative; a piece that draws on both the history of the Hall itself and on Bette's own memories of his East End (Hackney) 1950s adolescence.

The character who delivers the monologue (he never acquired a name) appeared to be in his sixties, and was wearing a very ordinary second-hand brown suit, a shirt and tie and pullover, worn and well-polished shoes. He was the sort of man who you could well see shopping with a single basket in one of the smaller, cheaper food shops on Dalston High Street. He was very quietly and 'respectably' spoken.

As the audience was ushered into its seats right at the back of the hall, there was the sound of an audience applauding politely – as if a lecture or speech had just finished. Then the house lights came up, revealing that the place was completely empty, except for an unoccupied lectern up on the stage, and a single elderly man sitting three rows from the front in an aisle seat, with a plastic carrier bag of shopping at his feet and his hat and coat on the seat next to him. After some time, he moved the carrier bag out of the aisle onto his lap; then turned round in his seat and started talking.

Does You Good

I enjoyed that, it was good, wasn't it.

Turns back to stare at the stage. Pause. Turns back to us.

I used to be at all the talks here, one time. It was a good place then – still is, I'm sure. Good people.

He decides to leave. Gets up, collects hat and coat and bag. This action continues in fits and starts all the way through to the end of the piece and his exit.

Some people used to come in just for a bit of a sit down and a sleep, well that was alright, nothing wrong with that if that was what they needed, but with me it was more, well, it was more what my mother used to call 'bettering yourself'.

Making things a little bit better always seemed a good idea to me.

Sort of usherette, I suppose I was. That used to be me up at the back there where you are – or down there by the exit doors doing the lights, seeing people out –

As if seeing people out.

> Teas in the hall.
> Yes, I did, too; very good, wasn't he.
> – in the hall, Mrs Aston.
> Yes, very informative, very.
> Round the left and downstairs on the right dear. (*This last* sotto voce *to Mrs Aston, and giving real directions to the actual toilets in the building.*)

She always had to go, Mrs Aston, and she never could

remember where it was – and I used to think: imagine getting old, not being able to remember what you knew last month, how funny. But now I have. And I can't. And it isn't.

Well not the little things I can't – recent things, last month, yesterday, but…

then…

then, I can.

I can remember how ugly it all was.

I can remember the bombsite still being out there where the new front door is now. I can remember Gardiner's Corner still being there on Aldgate. I can remember it still being fourpence all the way from Mare Street on the number twenty-two.

And I can remember being made *welcome* here. Which you weren't, always, *welcome*. Especially not if you were lower income people, or The Poor, which is what we were called then. And I can remember Mrs Aston (*Pointing out people as if he could see them sitting in different empty seats.*) And Mrs Aston's sister of course…Ernie, who did used to go to sleep, always…three of my mates, up at the back there…
…haven't seen him for years…
…Roger. Roger By Name, the girls used to call him…

Oh, lots of people.

Lots.

– well, we used to get a lot of people in for the talks, lots, very good speakers they always had here, prominent people; experts. All the old-time big do-gooders. Clem Attlee. Bernard Shaw, he was here. Lenin…politicians, too, Prime Ministers. All the personalities. Val Gielgud, the radio personality, he was very good, very good speaker, I

don't expect you remember him – no – you don't…; well
he was here, 'Speaking Up' his talk was, 'Speaking Your
Mind'… 'Broadcasting It', something like that anyway.
Very good. Val Gielgud…and of course there was the other
one. The brother. You know, you probably do remember
him, the brother, the one that was…

In 1953. The brother. 'Star Arrested.'

He puts his coat on.

I met him, the brother.

I did.

Met him here. Queuing up for his tea in the hall after,
he was, when his brother'd done his talk; come to meet
him, I suppose. Everybody knew who he was – well his
picture'd been in the *Mirror*, so everybody knew, even
Mrs Aston's sister. And of course he was a big star then,
big. Anyway you could hardly miss somebody wearing a
bloody gorgeous great posh suit like that in here, could
you. So there was I, taking the sixpences, and he was in the
queue, very down to earth like it always was here, and I
was thinking I wonder should I – sugar's on the table Mrs
Aston – say anything – yes very good wasn't it – oh dear
he's next, how funny, everyone knowing, and me knowing
that he's –

And him not knowing that I am too, and –

On the table dear –

…I think I blushed. 'Oh – Sixpence. Thank you. You're
welcome.'

Yes that's what I said to him. 'You're *welcome*.' Trying to
make it mean what I meant to say by the way I handed him

the cup. Well there was a room full of people – and what was I going to say to him – sorry to hear about your bit of bother Mr Gielgud, I know just how you feel. And what was he going to say to me? (*In Gielgud's voice.*) No milk, thank you, and do you go to the theatre?

Course I didn't talk to him. You didn't. Talk. Never bloody did. I never did anyway. Never. Good job too.

He's ready to leave; hat and coat on.

Just as well he never asked me that about the theatre, 'cause I didn't. Not to what you'd call the proper theatre. If I ever went up West it'd most likely be to a big musical show or the Palladium – I did have a friend who did the Vic a lot but I never used to think that was my sort of thing. Too much carrying on for me. Had some good times at the Palladium though we did. Johhny Ray. You probably don't remember him either do you, no, of course you don't. He was a bit special Johnny Ray.

What was special?

His skin. Pink, it was. That skin only blonde girls have usually.

His hair, obviously. Bit of a Tony Curtis in the front here.

And he cried. Cried. That was his schtick – big build-up, all the girls going crazy; pink skin, pink lights, tight trousers, wet seats all the way up to the dress circle – and then he'd go into his big number, 'Cry', it was called, 'Cry', he'd get down on his knees, and he'd –

– face all screwed up, like he couldn't stand it. Lovely.

Running down his face. Dripping off.

Lovely.

Men didn't you see. Not in those days. Never bloody
did. I never did. Never did. Never. And the funny thing
is, then, if you'd've asked me, I'd have said I didn't like
it. Embarrassing. Carrying on. 'I'm just here with my
mate's sister, she's mad about him.' – oh and she was;
mascara halfway down her face when the lights came up,
and tissues everywhere. Must have been terrible for the
usherettes there, having to pick all that up seven nights a
week and twice on Saturdays. I hate it when they do that,
leave tissues everywhere…

*He is now pottering along the rows picking up bits of litter – he has
forgotten about leaving and has unselfconsciously lapsed back into his
old role of usher.*

They got him, too, did you know that? Johnny Ray. 1958.
'Poor Bugger', one of my mates said to me at the time, and
I thought, I can remember thinking, you've got no idea,
have you?

Poor.

Bugger.

(*All tidy now; he's ready to go again.*) Right that's it then.
Quick check to make sure no one's left their handbag and
as I said, tea's in the hall, sugar's on the table and we look
forward to seeing you all next month, not sure what the
talk is but I'm sure it'll be something informative – So,
let's be having you now, thank you all for coming, last one
out's a sissy – (*Just when the audience thinks he is actually going
to ask them to leave, he spots a handbag that has been left – in Mrs
Aston's seat of course.*) – oh there's always one isn't there?
Always one leaves something. (*He looks inside.*) Mrs Aston.

All her bloody pension in it too – honestly, round here, it's not a good idea is it? It's alright, I'll hand it in at the office. It'll be alright there. Good to know there's still someplace where your stuff doesn't get nicked. Where they don't just want your handbag. (*There is anger underneath this; to himself.*) Yes…doing good, getting better, that's the thing.

Memories rising; he stands still.

'Does you good!', my mother used to say, but she only ever said it about punishments. Or medicine.

'Does you good!'

'All for the best.'

'Soon be feeling Better!'

(*Something gives way.*) Well I'll tell you what does me good. Remembering Johnny Ray at the Palladium. 'Remembering Johnny', that's what I'd give my talk about, if they asked me; if they ever asked me: 'Remembering Johnny'; personal memoirs of an old regular, featuring Johnny 'Poor Bugger' Ray and Johnny 'Star Arrested' Gielgud. (*He has got up on to the stage and now starts to use the lectern.*) Because you see I do remember. I remember handing him his cup and saucer, 'You're *welcome*', and I remember the pink skin, and the Tony Curtis, dripping right down off his face it was, not that I ever said anything out loud, never bloody did, I never did, never, but it doesn't mean I wasn't thinking it, doesn't mean I wasn't singing along all these years, doesn't mean if you listened very hard under the sound of all those girls screaming in the dress circle you wouldn't have heard me doing all the words under my breath –

In a gentle, broken whisper, his eyes closed, he sings:

If you're hurting, you can hide it, if you try;
But it's no secret, you'll feel better, if you cry.
When your life is like a bad dream
But it feels as though it's real,
And nobody knows the hurting that you feel –

If your heartache seems to hang around too long;
And your blues keep getting bluer with each song;
Remember sunshine can be found behind a cloudy sky
–
So let your hair down, and go on, and cry…

If your heartache seems to hang around too long;
And your blues keep getting bluer with each song;
Well now remember sunshine can be found behind a
 cloudy sky –
So let your hair down, and go right on baby and cry…

That's much better, thank you.

Very informative.

Does you good, coming here.

You're welcome.

By the last line he has collected himself, got down off the stage, and has the exit doors wedged open. After a last look round the empty room, he turns the lights off. We see him walking off down the corridor, whistling a quiet reprise of Johnny Ray's 'Cry', carrying Mrs Aston's handbag as well as his shopping.

Improbable
2004

This piece was written to be broadcast on Radio Four during the week leading up to St Valentine's Day in 2004. The brief was to write a monologue treating of contemporary romance, inspired by a contact ad found in a London paper. I wrote it on the understanding that it would be performed by my colleague, the actor John Quentin. Though it is a fiction, it was very much inspired by the particular qualities of his voice. And yes, the personal ad quoted at the beginning was a real one.

Improbable

Corner of Old Compton St, Tuesday May 9th.
You black polo jumper, me in light brown suit. You
waited, I flunked it. Could we talk?

Can I just say first of all that this isn't at all my usual way
of doing things? It's not me, really. Not really me at all.

I don't mean I haven't done, or don't still, occasionally do
things like trying to pick people up – because that wouldn't
be true – in fact that would be a ridiculous thing for me
to claim. After nearly fifty years as what the magistrates
always rather pompously used to call 'a practising', I should
have to say that I have, actually, had, over the years, rather
a lot of practice in that particular skill. No; what I mean, is
that I've never actually tried to do it like this before. Never
put an 'ad' in a magazine: never written a man I've never
even spoken to a letter like this one – that's what I mean. I
must say it does seem a very odd thing to be doing, at my
age.

I do wish I knew your name.

Of course, I'm not a fool; I know that the chances of
your seeing, never mind responding to my advertisement
are infinitesimal – the words needle and haystack spring
unbidden to mind. You may not even live in this country,
for all I know. And even if you do pick up a copy of the
free magazines from a bar or a café, as I think a lot of boys
of your age do, almost every week, who knows; next week
may well be the one week of this year that you don't –
and even if you do, what on earth are the chances of your
looking at the relevant page – and should you, well then, of

course, what are the chances of your noting my discreetly-worded little announcement amongst so many other much franker proposals? –

Listen to me. Being rational; calculating possibilities, being reasonable. That was my upbringing, and it's always been my vice. Well, since you will, most likely, never read this, I may as well be honest, and admit that when I think about you…about your face…I don't feel reasonable at all. Not really.

Not at all, actually.

Evidently; even the simple fact that I am sitting here and writing this must mean that in defiance of all probability I do actually, genuinely, really in some way believe that you not only might be but possibly even at this very minute are thinking about me; that even now at this very minute you are sitting at your kitchen table with a cup of coffee getting cold in front of you, thinking to yourself, – '*I wonder if that man in the brown suit…; after all, he did…and I…*' – oh how ridiculous I sound! What are the chances of that? Who on earth thinks that life works like that? Nobody, young man, of my age, I can assure you.

Nevertheless, here I am, sitting and writing to you.

Would it actually make things any easier if I knew your name? In my experience there are many things in life best said only to complete strangers.

Look I'm not going to even think about whether I'll ever send this to you. 'Hesitate, and the moment will be gone!!', as a dear friend of mine used to say – quoting whom, I have no idea. Except that I did – and, in all probability, it already has.

If you ever do read my advertisement, you'll see that I
have, as I said, been discreet – the habit of years I suppose
– and just described you as 'black polo jumper, May the
ninth'. But I wouldn't want you to think that that's all I
remember about you. I remember particularly the way
you were standing. I remember how very still you looked,
given that you'd obviously just walked out of that noisy
café – all that laughter ...quite still, quite...quiet. Sober.
Self-possession is the word I think I'm looking for – rare
in a man, perhaps especially in a young man – and on such
a busy street...I don't remember staring at you as I walked
towards you, but I realise now I think about it that I must
have been; staring; noticing the way your hair curled just
as it touched the black wool of your jumper at the back of
your neck. The fact that you hadn't shaved. Your skin, of
course – I wonder if you're Italian?...and then, when you
turned your head, and for some reason looked right at me
– I remember thinking, quick as a flash, before I even had
time to look away, Oh, that's odd; I'm smiling. I'm smiling
at him already. He must wonder why.

As if, on reflection, you don't get smiled at all the time.

The next thing I remember is looking down at the
pavement, and thinking *I must clean these shoes*, as I walked
past you – not looking at you, of course. I remember, and
this is odd I think, remember recalling the title of the book
that I was on my way to my bookshop on the Charing
Cross Road to try and find, *Don Juan*, a piece I've always
meant to read – and almost in fact saying it out loud, *Don
Juan*, as if that was my alibi, as if I wanted someone –
who? – to know that I had a perfectly respectable reason
for walking down this street of all streets, that I certainly
wasn't just strolling along staring at people... – and then

I can remember, twenty paces after walking past you, stopping, and looking back; and I can remember feeling that it was my body doing it, not my brain.

At my age. How odd that is. Should I know better?

God it's ridiculous that I don't know your name.

I looked back, and you were still standing there at the kerb, and were waiting – waiting; not looking in my direction, no, and perhaps frowning slightly I thought, but most definitely waiting. And I didn't stop, I walked on; another twenty paces, repeating in my head, *Don Juan, Don Juan*, and then I looked back again, and you were still waiting. And I, I…; I looked where I was going: as I was always, and so often, told one should. I looked neither to the right nor to the left, I looked where I was going, and I walked purposefully on to the corner, the corner of the Charing Cross Road; and I walked round it. And as I walked round it I, of course – *of course* – I let my eyes slide casually back in your direction. And there you still were, and you were, now – and I'm quite sure of this – smiling.

People always use the word 'casual', don't they, when they talk about us as if we didn't matter very much? As if something couldn't be serious just because it is sudden. Well the way you looked at me, young man, there was nothing casual about it. You looked right at me. You'd never met me, never spoken to me, knew nothing about me – and yet right there, right down the length of that long and very crowded pavement, you deliberately looked right into my eyes. Right directly into them.

And from the way you did it, I wouldn't say actually that you are a quiet person at all. Not when someone gets to know you. Self-possessed, yes, but not a quiet or a still

person at all. Not with eyes like that. When someone looks at you with eyes like that, straight at you, it means, in my experience, in general, *yes*. That's what it means. Not *No*. It means *Yes*. The soundtrack fades on the film and you can almost hear the word being…almost hear your own voice saying it out loud in your head, *Yes*. I was forty feet away from you, and yet your eyes were looking so straight into mine you might as well have been a reflection in a mirror held only inches away from my face. So close, the breath from my open mouth could mist the mirror…

– this all feels like it took ages now that I'm trying to write to you about it but I suppose the whole thing must have lasted only a minute at most, I mean from Dean Street down Compton Street and round the corner into the Charing Cross Road, that can only be what, a minute, can't it, at most; – and when I got round the corner, and stopped, I suddenly felt my face burning. And I felt such a fool. Such a fool. And God knows why, but I took a deep breath, and I turned round and I walked back round the corner onto Compton Street – and of course – of *course* – you'd gone.

I knew at the time, when I saw you were waiting, I knew then I should have stopped and turned back and talked to you, not walked on, I knew that was what I should have done; but I just couldn't face the sheer unlikeliness of it you see; the sheer improbability of my walking up to somebody as beautiful as you in broad daylight and saying – what? What could I have possibly said? I mean, you, a young man like you, and myself, myself in my weekday brown suit – no one would ever put us together in a million years. It would have been…preposterous.

Well that, my dear – forgive me, but in the absence of my

knowing your name, that will have to do; – that, my dear, is, I suppose, why I am writing to you.

Every meeting is preposterous.

Every pairing is unlikely.

Every union, impossible.

There's a marvellous moment in *Don Juan* – which I did find rather a good copy of, by the way, when I finally made it to my bookshop – where the Don's manservant appals him by saying, 'Surely, Sir, everybody has to believe in something.' Don Juan – who in Molière's play is an older man, not my age quite, but certainly older – is so shocked to find that somebody is still prepared to say that, still prepared to use the word *believe* like that, outloud, that he lapses into disgruntled and entirely uncharacteristic silence for several minutes. Well, much to my surprise, I find I agree with that servant. Everybody does have to believe in something. When I was your age, I was told that meetings between strangers like us not only shouldn't happen, but couldn't happen and in fact didn't, ever. Fortunately, I was lucky; I found out quite quickly that that was all nonsense. But these days it does seem to me that too many people think that the only meetings worth anticipating are the likely ones. The predictable ones; the probable. And I believe – and I realise now that I've always believed, ever since I was your age, except I think I may have forgotten this for a while, until the sight of you standing on that pavement last Wednesday made me remember – that there's no such thing.

Of course, when – if – two strangers speak, then I suppose it doesn't actually matter what then happens; it doesn't matter what is actually said; it doesn't matter how old you

are or what street you're on; but it does matter terribly that one doesn't walk past, that one doesn't just walk past, that one doesn't walk past with one's eyes cast down.

So, on reflection, *pace* the beginning of this letter, can I end by saying that now my cup of coffee is entirely cold, and now that I've said what I felt I had to say, that this is the real me, probably. This, the man writing these things to you, is me.

My name, by the way, is David.

Sincerely –